Rob Sheppard
S Digital Rebel
S 300D Digital

D0290929

Magic Lantern Guides

Canon
EOS REBEL DIGITAL
EOS 300D
DIGITAL

Rob Sheppard

LARK BOOKS
A Division of Sterling Publishing,Co., Inc.
New York

Layout: Michael Robertson
Photography by Rob Sheppard unless otherwise indicated
Cover Designer: Barbara Zaretsky
Editorial Assistance: Delores Gosnell

10 9 8 7 6 5 4 3 2 1
First Edition

Published by Lark Books, a division of
Sterling Publishing Co., Inc.
387 Park Avenue South, New York, N.Y. 10016

© 2004, Rob Sheppard

Library of Congress Cataloging-in-Publication Data

Distributed in Canada by Sterling Publishing, c/o Canadian Manda Group,
One Atlantic Ave., Suite 105, Toronto, Ontario, Canada M6K 3E7

Distributed in the U.K. by Guild of Master Craftsman Publications Ltd., Castle Place, 166 High Street,
Lewes, East Sussex, England BN7 1XU; Tel: (+ 44) 1273 477374, Fax: (+ 44) 1273 478606,
Email: pubs@thegmcgroup.com, Web: www.gmcpublications.com

Distributed in Australia by Capricorn Link (Australia) Pty Ltd., P.O. Box 704, Windsor, NSW 2756 Australia

If you have questions or comments about this book, please contact:
Lark Books
67 Broadway
Asheville, NC 28801
(828) 253-0467
Printed in China

ISBN: 1-57990-589-7

Contents

With the Canon EOS Digital Rebel, you can share special events and moments immediately with family and friends. (© Kevin Kopp).

well as with color film. Black-and-white silver-based film exhibits more grain during overexposure. Sensor noise may also be increased with long digital exposures under low-light conditions.

File Formats & Resolution

A digital camera processes image information from the sensor by converting it to digital data. Typically, the conversion results in 8 or 12-bit color data for each of three different color channels employed by the Digital Rebel: red, green, and blue. A bit is the smallest piece of information that a computer uses—an acronym for binary digit. Eight bits make up a byte.

One great feature of the Digital Rebel is its ability to capture a RAW file. Canon calls its proprietary RAW files CRW files. They are image files that have little processing applied by the camera. They also contain 12-bit color information, which gives more data than some other file types. Also, when you work with the RAW file in your computer, you have greater technical control over the image because you are starting with more complete data than other file forms can offer (i.e. JPEG or TIFF). Not all image-processing programs can open RAW files. However, Canon does supply a dedicated software program with the camera that will allow you to open and process CRW files. You can then save them to a format that your image-processing program can open.

JPEG is a standard format for image compression and is the most common file created by digital cameras. Digital cameras use this format because it reduces the size of the file, allowing more pictures to fit on a memory card. Before a photo is actually recorded in JPEG form, proprietary camera treatments take effect. Usually, the camera has a unique processing chip that evaluates the captured 12-bit image, makes adjustments to maximize the data, and then compresses the image with a reduced color depth of 8-bit

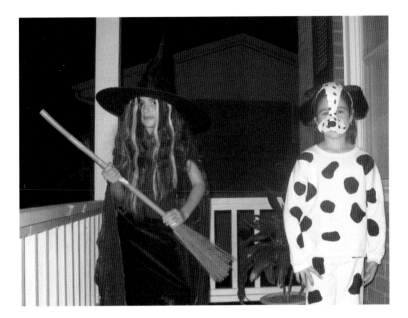

With the Canon EOS Digital Rebel, you can share special events and moments immediately with family and friends. (© Kevin Kopp).

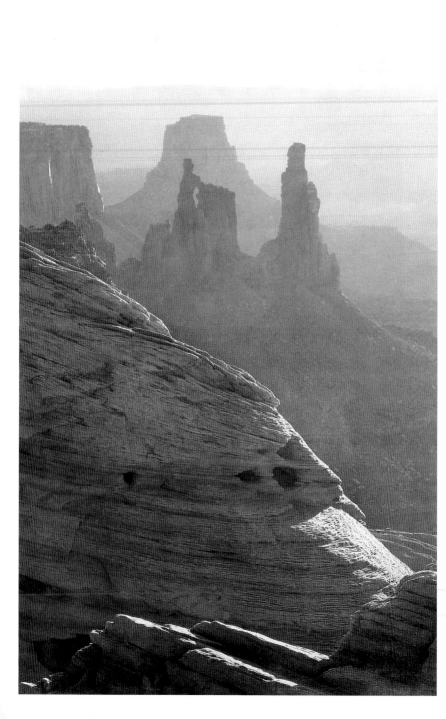

Understanding Digital Photography

The Excitement of Digital Photography

Since the invention of photography, taking pictures has been a favorite pastime. Now, due to the introduction of digital photography, people are more interested than ever in creating images and preserving memories. One thing is certain – owning a digital camera is a sure way to discover new excitement and enthusiasm for photography. With its innovative features, the Canon EOS Digital Rebel single-lens-reflex camera is destined to play a leading role in making digital photography a household word.

Digital Camera Features

There are some special things that digital cameras do differently than traditional film cameras that make them exciting and fun to use. However, at first, some of these differences may seem complicated or confusing. Though most of the features found on a traditional Canon Rebel camera are also available on the Digital Rebel, there are many new controls and operations you've probably never used before. Many have been added to increase the camera's versatility for different shooting styles and requirements. This doesn't mean you have to master all of them. It is important to remember that with today's automated, full-feature cameras, it is not necessary to be an expert to get great results. The goal of this manual is to help you understand how the camera operates so that you can choose the techniques that work best for you and your style of photography.

From landscapes to close-ups, the Canon EOS Digital Rebel is capable of capturing clear, sharp images as good as those possible with film.

Differences between Digital & Film Photography

Just a few years ago it was easy to tell the difference between photos taken with a digital camera and those shot with a traditional film camera. This was because pictures from digital cameras didn't measure up in quality. However, this is no longer true. With the Canon EOS Digital Rebel you can easily make pictures 8 x 10-inches or larger that will look as good or better than an enlargement from 35mm film.

While there are differences between these two types of image capture, there are many similarities as well. A camera is basically a box that holds a lens to focus the image. The amount of light entering this box is regulated by adjusting the opening in the lens (f/stop) and by selecting the shutter speed, which controls the amount of time light strikes the light-sensitive medium (film or sensor). The difference, of course, is that in traditional photography, the image is recorded on film and later developed with chemicals, whereas in digital photography the camera converts the light to an electronic image. The digital camera does more to the captured image than a film camera in terms of internal processing. While many exposure techniques remain the same, understanding what's different about digital photography will help you take advantage of the many enjoyable and creative possibilities of this new technology.

Film vs. the Sensor

Both film and digital cameras expose pictures using virtually identical technologies. The light measuring (metering) systems are the same, the film and sensor sensitivity standards are similar (both based on ISO speeds – International Standards Organization), and the shutter and aperture mechanisms controlling the amount of light admitted into the camera are the same. These similarities exist because both film and digital cameras share the same goal: to deliver the appropriate amount of light required by the film or sensor to create a picture you will like.

Not surprisingly, digital sensors respond differently to light than film does. From dark areas (such as navy blue blazers, asphalt, and shadows) to midtones (blue sky and grass) to bright areas (such as white houses and sand beaches), a digital sensor responds to the full range of light equally, or linearly. Film, however, responds linearly only to midtones (those blue skies and green fairways). Therefore, film blends tones very well in highlight areas, whereas digital sensors often cut out the bright tones. Digital responds to highlights like slide film and shadows like print film.

With both film and digital cameras, many things happen between the time that you take the picture and the time you see it. And, although film reacts differently to light than a digital sensor, the end result is quite similar. So similar, in fact, that most people would be hard pressed to tell the difference between a digital and a film print.

LCD Monitor

One of the major limitations of film is that you really don't know if your picture is a success until the film is developed. You have to wait to find out if the exposure was correct or if something happened to spoil the results (such as the blurring of a moving subject or stray reflections from flash). With digital cameras, you can see an image on the LCD monitor within seconds of taking the shot. While the LCD monitor will not reveal all the minute details, it is great for a general idea of what has been recorded. Furthermore, the Digital Rebel offers a graphic representation of exposure values, called a histogram (explained on page 73), via the LCD. The ability to see the recorded picture combined with its exposure details means that under and overexposure corrections, lighting problems, and compositional issues can be dealt with on the spot. Flash photography in particular can be checked not only for correct exposure but also for other factors, such as the effect of lighting ratios when multiple flash units and/or reflectors are used. No Polaroid film test is needed. Instead you can see the actual image that has been captured by the sensor.

Film vs. Memory Cards

Memory cards are necessary to store images captured by a digital camera. These removable cards affect photographic technique and offer several advantages over film, including:

1. *More photos:* Standard 35mm film comes in two sizes: 24 and 36 exposure. Memory cards come in a range of capacities, and all but the smallest are capable of holding more exposures than film (depending on the selected file type).

2. *Removable photos:* Once you make an exposure with film, you have to develop and store the negative and print. Due to a chemical reaction, the emulsion layer is permanently changed and thus, the film cannot be reused. With a memory card, you can erase photos at any time, removing the ones you don't want while opening space for additional photos, simplifying the process of dealing with and organizing your final set of images. Once images are transferred to your computer (or other storage medium – burning a CD is recommended), the card can be reused.

3. *Durability:* Memory cards are much more durable than film. They can be removed from the camera at any time (as long as the camera is turned off) without the risk of ruined pictures, and even taken through the airport carry-on inspection machines without suffering damage.

4. *No ISO limitations:* Digital cameras can be set to record at a number of different ISO speeds. This can be done at any time, and the card in the camera will capture pictures using any of these different ISO settings.

5. *Small size:* In the space taken up by just a couple of rolls of film, you can store or tote multiple memory cards that will hold hundreds of images.

6. *Greater image permanence:* The latent image (exposed but undeveloped film) is quite susceptible to degradation. This is often a concern of pros on the road because

atmospheric conditions such as heat and humidity can wreak havoc on already-shot film. With new security monitors for packed and carry-on luggage, this is even more worrisome. Traveling photographers find that digital photography allows them much more peace of mind. Not only are memory cards are more durable, but their images can also be easily downloaded into storage devices or laptops.

Exposure & the Histogram

One thing that remains true, whether you are shooting film or digital, is that the wrong exposure will cause problems. Digital cameras do not offer any magic that lets you beat the laws of physics. Too little light makes dark images; too much makes overly bright images. (However, it is entirely possible that with new in-camera processing technologies, highlight exposure challenges may be less of an issue in the future.) Remember, the LCD monitor will give you an essentially instantaneous look at your exposure and, while this tiny version of your image isn't perfect, it will give you a good idea of whether you are exposing properly or not.

With traditional film, many photographers regularly bracket exposures (reshoot the same image several times with changed settings) in order to ensure they get the exposure they want. You can still bracket with digital if you want to, but there is less of a need for it because you can check your exposure as you go. One great way to evaluate your exposure is by using the Digital Rebel's histogram function. This feature is explained later (see page 73) but, basically, it offers you a readout of the brightness values of the photo. This capability is unique to digital photography and is a feature of the Digital Rebel (though not all digital cameras have this feature).

On a foggy day such as this, double-checking your exposure on the LCD monitor can help to ensure that your photo is exposed properly.

ISO

ISO is an international standard method for quantifying a film's sensitivity to light. Once an ISO number is assigned to a film, you can count on it having a standard sensitivity, or speed, regardless of the manufacturer. Low numbers, such as 50 or 100, represent less sensitivity, and films with these speeds are called slow films. High numbers, such as 400 or 800, show that a film is much more sensitive and are referred to as fast films. ISO numbers are mathematically proportional to their sensitivity to light. As you double or halve the ISO number, you double or halve the film's sensitivity to light (i.e. 800 speed film is twice as sensitive to light as 400 speed, and 800 speed film is half as sensitive to light as 1600 speed).

Technically, digital cameras do not have a true ISO. Unlike film, a sensor and its circuits do not have a specific sensitivity. However, manufacturers have developed ways to make a sensor respond similarly to the way film responds. A digital camera does have ISO equivalent settings that correspond to film, so that if you set a digital camera to ISO 400, you can expect a similar response to light as an ISO 400 film would exhibit.

Changing ISO picture-by-picture is easy with a digital camera, but generally not possible with film unless you are constantly reloading rolls of varying film speeds into the camera. With a digital camera, you actually change the sensitivity of the sensor and its circuits when you change the ISO setting. It's like changing film at the touch of a button. This capability provides many advantages – for example, you could be indoors using an ISO setting of 800 so you don't need flash, then follow your subject outside into the blazing sun and change to ISO 100.

Noise & Grain

Noise is the digital equivalent of grain, which is an issue in both film and digital photography. It appears as an irregular, sand-like texture that, if large, can be unsightly and, if small, is essentially invisible. (This textured look is sometimes desirable for certain creative effects.) In film it occurs due to the chemical structure of the light sensitive materials. With digital cameras, it occurs for several reasons: sensor noise (caused by heat from the electronics and optics), digital artifacts (when digital technology cannot deal with fine tonalities such as sky gradations) and JPEG artifacts (caused by image compression). Sensor noise is the most common.

In both film and digital, grain or noise will emerge when using high ISO speeds. High-speed films exhibit more grain than low-speed, and high ISO settings on digital cameras show more noise. In addition, noise and grain will be even more obvious during underexposure with digital cameras, as

well as with color film. Black-and-white silver-based film exhibits more grain during overexposure. Sensor noise may also be increased with long digital exposures under low-light conditions.

File Formats & Resolution

A digital camera processes image information from the sensor by converting it to digital data. Typically, the conversion results in 8 or 12-bit color data for each of three different color channels employed by the Digital Rebel: red, green, and blue. A bit is the smallest piece of information that a computer uses—an acronym for binary digit. Eight bits make up a byte.

One great feature of the Digital Rebel is its ability to capture a RAW file. Canon calls its proprietary RAW files CRW files. They are image files that have little processing applied by the camera. They also contain 12-bit color information, which gives more data than some other file types. Also, when you work with the RAW file in your computer, you have greater technical control over the image because you are starting with more complete data than other file forms can offer (i.e. JPEG or TIFF). Not all image-processing programs can open RAW files. However, Canon does supply a dedicated software program with the camera that will allow you to open and process CRW files. You can then save them to a format that your image-processing program can open.

JPEG is a standard format for image compression and is the most common file created by digital cameras. Digital cameras use this format because it reduces the size of the file, allowing more pictures to fit on a memory card. Before a photo is actually recorded in JPEG form, proprietary camera treatments take effect. Usually, the camera has a unique processing chip that evaluates the captured 12-bit image, makes adjustments to maximize the data, and then compresses the image with a reduced color depth of 8-bit

to save the file in JPEG format. Because this process discards what it deems "redundant" data, JPEG is referred to as a "lossy" format. Keep in mind, however, that when the file is opened in a computer the lost data is actually rebuilt quite well, especially if the compression is low (i.e. the picture was taken using high quality settings). In addition, quality is maintained by not reusing the JPEG format in the computer. In other words, once opened, the file should be saved in TIFF format or in the image-editing software's native format (such as Photoshop's ".psd").

Both RAW and JPEG files can give excellent results. The unprocessed data of a RAW file can be helpful when faced with tough exposure situations, but the small size of the JPEG file is faster and easier to deal with.

For most purposes it usually doesn't matter whether an image originated as a RAW or high-quality JPEG file. What matters most to professional art directors, clients, or friends and relatives is the appearance of the image; how it communicates and how well it fulfills its purpose as a snapshot, a framed piece of art, an email attachment, or a magazine photo. You don't have to shoot in one particular format or the other on order to create publishable files. Both JPEG and RAW work extremely well.

The most important factor in deciding which format will work best for you is your own personal shooting and working style. If you want to shoot quickly and spend less time in front of the computer, JPEG might be the best file for you. If you loved working in the darkroom and processing film, then RAW is a great continuation of that process. If you are dealing with problematic lighting, RAW may give you the best results. If you have tons of images to deal with, JPEG may be the most efficient.

JPEG or RAW formats are as much reflections of your photographic style as they are formats for capturing images (JPEG is technically a compression scheme and not a true format, but it is effectively used as a format). The key is to be

aware of how you like to work and what results you need. You have to test the formats for yourself with your camera and its software to see if you gain anything using one over the other.

RAW Exposure Processing

There are several choices available for processing RAW files. You can use Canon's software (which is an advantage because it has been designed specifically for the Digital Rebel's CRW files), or you can elect to try other processing programs that make conversions from RAW files even easier, such as PhaseOne's Capture One software. These independent software programs are often intended for professional use, however, and can be expensive. Their advantage tends to be ease-of-use for better processing decisions and sometimes better processing algorithms than the camera manufacturer's proprietary programs.

The disadvantage of most RAW conversion programs is that they are not integrated into any image-editing software. This means you have to open and work on your photo, then save it and reopen it in an editing program, such as Adobe Photoshop Elements. Adobe met this challenge by including RAW conversion capabilities in their latest software, Photoshop CS (there is a RAW plug-in available that works similarly for earlier versions). This means you can open a RAW file directly in Photoshop, do the conversions, and then continue to work on the file without leaving the program. Workflow is much improved and control over the RAW file is quite good, although some photographers still prefer the conversion algorithms of other programs.

Whatever method you choose to gain access to RAW files in your computer, you will have excellent control over the images in terms of exposure and color of light. The image will appear showing the exposure settings you selected when you first shot it and you can then change these exposure values without causing harm to the file. Most RAW soft-

When you shoot your image using the RAW file format, you will have greater technical control over the final, image-edited product.

ware allows batch processing. This allows you to adjust a group of photos to specific settings and can be a very important way to deal with multiple photos from the same "shoot."

Defining Resolution

When we talk about resolution in film, we are simply referring to film or the detail that the film can see or "resolve." Resolution in a lens (the detail a lens can resolve) generally doesn't change. Unfortunately, resolution is not as simple a concept when it comes to digital photography.

Resolution in the digital world is expressed in different ways depending on what part of the digital loop you are working in. For example, in the case of digital cameras, res-

olution indicates how many individual pixels are contained on the imaging sensor. This is usually expressed in megapixels. Each pixel captures a portion of the total light falling on the sensor. And it is from these pixels that the image is created. Thus, a 3-megapixel camera has 3-million pixels covering the sensor. On the other hand, when it comes to inkjet printing, the usual rating of resolution is in dots-per-inch (dpi), which describes how many individual dots of ink exist per inch of paper area, a very different concept.

Dealing with Resolution

The resolution capacity for each image captured by your camera is usually expressed in terms of megapixels, or millions of pixels. The Digital Rebel offers seven different resolution settings (detailed on page 53) that you can choose from so that you don't always have to utilize the camera's maximum resolution, but generally it is best to use the highest setting available (i.e. get the most detail possible with your camera). You can always reduce resolution in the computer, but you cannot recreate detail if you never captured the data to begin with. Keep in mind that you paid for the megapixels in your camera! The lower the resolution you are shooting with, the less detail your picture will have. This is particularly noticeable when making enlargements.

There are situations where it may be preferable to shoot at a resolution that is less than maximum capacity. For example, if you know you will only be using the photo for emailing or webpage purposes, you probably don't want a large file size. Lower resolution image files will also save storage space and processing time. You can fit more low-resolution images on your memory card than those captured using higher resolution settings. These small files (starting at about 640 x 480 pixels) are easier to transport. (File sizes, when listed in pixels, appear as a larger number multiplied by a smaller number.) To determine how large a print you can make (with acceptable resolution quality) simply divide each of the pixel equation numbers by 200 (the 200 refers to a

linear print resolution of 200 dpi). The resulting numbers will give the size in inches. (A file recorded at 640 x 480 pixels, for example, would only produce a fully photo-quality image up to the size 3.2 x 2.4 inches!)

Digital camera files generally enlarge very well in programs like Photoshop, especially if you shot them in RAW format first (because there is more data in that format to work with). The higher the original shooting resolution, the larger the print you can make. Again, if the photos are specifically for email or webpage use, you do not need to shoot with a high resolution in order for the images to look good on screen.

White Balance

Most pros who have shot film over the years can tell you about the challenges faced when balancing their light source with the film's response to the color of light. If you shoot a daylight-balanced (outside) film while indoors, your image will have an orange cast to it. Accurate color reproduction in this instance would require the use of a color correction filter. One of the toughest lights to balance is fluorescent. The type and age of these bulbs will affect their color and how that color appears on film, usually requiring filtration. Though filters are helpful in altering and correcting the color of light, they also darken the viewfinder, increase the exposure, and make it harder to focus and compose the image.

With the digital camera, all this has changed. Color correction is managed by the white balance function, an internal setting built in to all digital cameras. It has long been a part of video – news videographers, for example, have white-balanced their cameras as a standard practice since portable color cameras became available approximately 30 years ago. This allowed the cameras to use electronic circuits to neutralize whites and other neutral colors without using filters.

The digital camera works the same way. It can automatically check the light and calculate the proper setting for the light's color. It can also be set to specific light conditions, or it can be custom-set for any number of possible conditions. Regardless, filters are rarely a necessity, making light-loss a non-issue.

Digital vs. Optical Zoom

Digital zoom is entirely different from optical zoom. Optical zoom uses the lens to focus on and enlarge the details of your subject. Digital zoom, though it does magnify the image, captures no new details. It actually crops and saves a small portion of the sensor's data, disregarding the rest. It then interpolates this new, smaller portion of the data (meaning it fills in pixels) to amplify it back to the original size of a full file. It can only work from the maximum detail captured in that segment of the original image. It cannot reconstruct genuine detail. For this reason, digital zoom is never as authentic as optical. In fact, Canon has excluded digital zoom from the Digital Rebel to ensure optimal picture quality.

Cost of Shooting

While film cameras have traditionally cost less than digital cameras, an interesting phenomenon is taking place. Memory cards are becoming increasingly less expensive. Once a card is purchased, it can be used again and again. Therefore, cost per image decreases as the use of the card increases. Conversely, the more pictures you take with film, the more rolls you have to buy, the more expensive the photography becomes.

This gets very interesting when you talk to pros in fields such as sports photography or photojournalism who work under the theory that "film is cheap." This is because getting the shot is what matters, regardless of the quantity of film used. Yet these same photographers often don't like "wasting film," and this can influence some of their shooting.

With the Digital Rebel, you can let your creativity run wild without fear of wasting film.

Enter digital cameras. Now there is literally no cost to shooting a large number of photos. The camera and memory card are already paid for, whether one, ten, or a hundred images are shot. This can be liberating because now photographers can try new ways of shooting, experiment with creative angles never attempted before, and so much more. Any shots that don't work out can simply be erased.

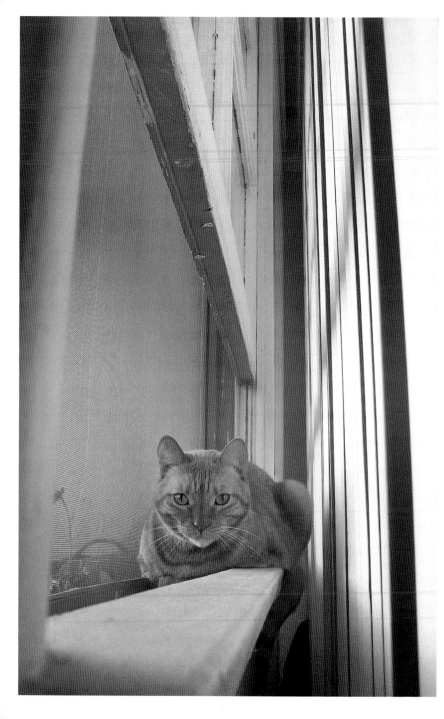

Introducing The Canon EOS Digital Rebel

The Canon EOS Digital Rebel (also called the EOS 300D and the KISS Digital outside North America) is the first popularly priced, consumer digital, interchangeable-lens SLR (single lens reflex) camera. The camera is based on a venerable Canon Rebel camera concept of building inexpensive, yet full-featured SLRs – affordable cameras that can be enjoyed by large numbers of photographic enthusiasts.

This book is designed to help you get the most out of your Digital Rebel (we'll use this "nickname" instead of the full model name). Unlike the camera's instruction manual, this guide will help you understand all of the camera's features and give tips on how you can best use them. Camera manu-

Use the Digital Rebel to experiment with unique camera angles, and only keep the shots you like.

facturers today offer a lot of features with their cameras. They do this to appeal to many buyers, but you may not need or use them all. Hopefully this book will give you an idea of what is possible with the features you have yet to try, as well as help you to either better use them or not feel guilty that you don't! The most important thing is that you understand the features of your camera so that you can make the best choices for your shooting style and get maximum enjoyment and great pictures from this innovative digital camera.

Spend some time with your camera; get to know it in casual shooting situations. Many camera store owners tell tales of customers who buy a new camera just before leaving on a once-in-a-lifetime trip to Africa only to not use it to its potential, or worse, have the camera totally fail for him or her.

With digital cameras, you can't "waste film." You can shoot as much as you want and then erase it all. This is important because it means you can literally try out every feature you want with your camera and actually see what it does immediately. This is a quick and sure way of learning to use your camera.

This book is not written with the thought that you should start at the beginning and read it like a novel. Skip around as needed, read whole chapters where they interest you or just hit highlights of key features that you have to know right now.

Note: When the terms "left" and "right" are used to describe the locations of camera controls, it is assumed that the camera is being held in shooting position unless otherwise specified.

Basic Info

The Digital Rebel is small for a digital SLR. The body measures 5.6 x 3.9 x 2.9 inches (about 14.2 x 9.9 x 7.4 cm) and weighs just over a pound at 19.7 oz (558.5 g). It is an interchangeable lens, digital single-lens-reflex camera (SLR) that has full autofocus and autoexposure capabilities. It uses either

Canon EOS Digital Rebel Front View

1. Shutter button
2. Red-eye reduction/Selftimer lamp
3. Mode dial
4. Built-in pop-up flash
5. Flash button (beside lens)
6. Lens release button
7. Depth-of-field preview button (beside lens)
8. Grip (battery compartment)
9. Remote control sensor
10. Main dial

Type I or Type II CompactFlash (CF) memory cards for its recording medium. The camera is compatible with Canon EF lenses (including EF-S) and accepts aftermarket lenses with the Canon EF mount.

The Imaging Sensor

The camera's imaging sensor is a high-intensity, high-resolution, single-plate, color CMOS (complementary metal-oxide semiconductor) element. It has an area of 3072 x 2048 pixels for approximately 6.3 million total pixels (or megapixels) –

Canon EOS Digital Rebel Rear View

1. Menu button
2. Viewfinder eyepiece
3. Dioptric adjustment knob
4. LCD panel illumination button
5. Aperture value/Exposure compensation button
6. Mode dial
7. AE lock/FE lock/Index/ Reduce button
8. AF point selector/ Enlarge button
9. CF card slot cover
10. ISO speed set button/ Cross key up
11. Cross key right
12. Setting button
13. Access lamp
14. Battery compartment release button (bottom)
15. White balance button/ Cross key down
16. Cross key left
17. Tripod socket (bottom)
18. LCD monitor
19. LCD panel
20. Erase button
21. Playback button
22. Jump button
23. Info button

these are the effective pixels used by the camera for the image (the actual sensor is slightly larger). The sensor itself is 0.59 x 0.89 inches in size, which is smaller than the 35mm film size of 1 x 1.5 inches, and has an aspect ratio of 2:3. The result is that lens focal lengths do not react the same as on a standard 35mm camera. (To determine the effective

Canon EOS Digital Rebel Top View

1. Interchangeable lens
2. Built-in flash
3. Red-eye reduction/
 Self-timer lamp
4. Grip
5. Shutter button
6. Main dial
7. Drive mode selection button
8. Strap mount
9. Mode dial
10. Flash-sync contacts
11. Eyecup
12. Hot shoe
13. Strap mount
14. Lens release button

focal length of a zoom lens with the Digital Rebel, multiply both the focal length of the widest angle and the farthest zoom by 1.6. These two new numbers reflect the range of the lens when used with this camera.)

The sensor uses an RGB primary color filter in a standard Bayer pattern over the sensor elements. This is an alternating pattern of color with 50% green, 25% red and 25% blue – full color is interpolated from this data. In addition, an infrared-cut low-pass filter is located in front of the sensor. This three-

layer filter is designed to prevent the false colors and wavy or rippled surface patterns that can occur when photographing small, patterned areas with high-resolution digital cameras.

The Recording System

Like most digital SLRs, the Digital Rebel records images in compressed format using JPEG and RAW files (Canon's proprietary RAW files are called CRW files). The JPEG files are fully compliant with the formatting device EXIF 2.2 – Exchangeable Image File Format. EXIF allows special information about the camera's settings to be recorded with the photo.

JPEG files have low compression (6:1) for Fine resolution settings and moderate compression (10:1) for Normal resolution settings. Both are relatively mild compression levels for JPEG. The Digital Rebel records six types of JPEG files based on compression and pixel dimension. These files range from the full format size of 6 megapixels in the 'L' or Large setting, down to approximately 1.6 megapixels in the 'S' or Small setting. A 6-megapixel photo will take up about 3.1 MB (megabytes) of space on your CF memory card (this cannot be given exactly since JPEG is a variable compression format). A 1.6-megapixel photo takes up about 0.9 MB of space. RAW files take up more than double the space of a 6-megapixel photo; they are approximately 7 MB in size.

The Viewfinder

The Digital Rebel uses a standard eye-level SLR viewfinder with a fixed pentamirror. Images from the lens are reflected to the viewfinder with a quick-return semi-transparent half mirror (you can use up to an EF 600mm f/4 telephoto lens without experiencing mirror cutoff). The viewfinder shows approximately 95% of the actual image area captured by the sensor (although the LCD review shows closer to 100%). The eyepoint is 21 mm (good for people with glasses), plus there is a built-in adjustable diopter correction of –3 to + 1.

Viewfinder Information

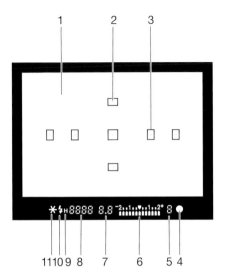

1. Focusing Screen
2. AF point display indicator
3. AF points
4. Focus confirmation light
5. Maximum burst during continuous shooting
6. Exposure compensation / AEB / Red-eye reduction indicator
7. Aperture value
8. Shutter speed / FE lock / Busy / CF card warning
9. High-speed sync
10. Flash-ready / Improper FE lock warning
11. AE lock / FE lock / AEB in progress

The focusing screen is fixed and the viewfinder provides 0.8x magnification. The viewfinder display includes a great deal of information about camera settings and functions, though not all this data is available at once. The camera's seven autofocus (AF) points are on the focusing screen, and the solid band at the bottom of the focusing screen shows the shutter speed, f/stop, and AF/MF (auto/manual) focus confirmation (a circle appears on the far right when the camera is in focus). (See diagram above.)

There is no eyepiece shutter to block light entering the viewfinder when it is not against the eye (which does affect exposure). However, there is an eyepiece cover provided. Depth of field can be previewed through the viewfinder by using the depth-of-field preview button beside the lens.

Viewfinder Adjustment

The Digital Rebel's viewfinder features a built-in diopter (a supplementary lens that allows for sharper viewing). To see the focusing screen properly, you do need to adjust the diopter for your eye. The diopter will help you get a sharp view of the focusing screen so you can be sure you are getting the correct sharpness as you shoot. You can set it by looking through the viewfinder and directing your eye to the AF points. Then, move the dioptric adjustment knob (on the right side of the eyecup) up and down until the AF points appear sharp.

Some Canon literature claims you can use this to see through the camera comfortably with or without eyeglasses, though I have found that the correction isn't really strong enough for most people who wear glasses regularly.

Autofocus (AF)

Autofocus is accomplished through the lens with the use of the special CMOS sensor dedicated to AF. The camera has seven AF points that work with an EV (exposure value) range of 0.5-18 (at ISO 100), which basically covers most common photographic light levels except for very low light indoors and at night (there is an AF-assist beam for dark conditions that comes from the built-in flash). AF points are superimposed in the viewfinder. They can be used automatically (the camera selects them as needed) or you can choose one manually. (See page 128 for manual AF point selection instructions).

AF focusing modes are automatically selected by the camera and include One-Shot AF, Predictive AI Servo AF and AI Focus AF. The camera can also be manually focused as needed. (See page 130 for more about the different focusing modes.)

34

The Mode Dial is located on the top right of the camera body.

Exposure Modes

The Digital Rebel has four user controlled exposure modes, plus a special purpose mode for depth of field. It also offers a basic or fully automatic mode that does not allow any adjustments, and six additional automatic modes that Canon calls Programmed Image Control modes (PIC). These various exposure modes are useful because they make the camera more adaptable to different photographers' needs. There is something for everyone, but not every photographer will use all these modes.

The camera is divided into two main areas on the Mode Dial – The Basic Zone and the Creative Zone, separated in the middle of the dial by Full Auto ☐. The Basic Zone (which Full Auto is considered to be a part of) includes all the PIC fully automatic camera modes – Portrait, Landscape, Close-Up, Sports, Night Portrait, and Flash Off (all located below Full Auto). The Creative Zone allows the photographer more control over the camera's exposure. Program AE (autoexposure), Shutter-priority AE, Aperture-priority AE, Manual exposure, and Automatic Depth-of-field AE are all Creative Zone modes, and are located above Full Auto on the Mode Dial. (See page 84-99 for more on the exposure modes.)

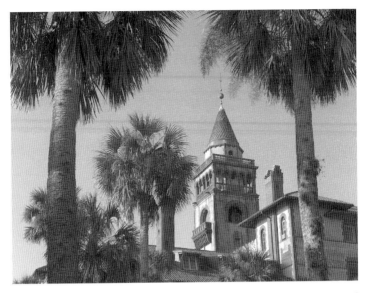

With your Digital Rebel, you can easily capture sharp pictures of buildings and landscapes by using the Landscape mode, one of the selections within the PIC modes.

Exposure Control

The Digital Rebel has several light metering modes that solve varied photographic challenges. The metering system has an EV (exposure value) range of 1-20 (at ISO 100).

- Evaluative metering uses 35 zones throughout the image area, then internal processing in the camera evaluates and compares the zones for proper exposure.
- Partial metering just looks at the center of the image (approximately 9% of the viewfinder).
- Center-weighted metering is always chosen for manual exposures. It averages metering zones from across the entire image area, favoring the center of the picture.

Exposure control is accomplished through a series of choices found on the camera's Mode Dial. The photographer has degrees of exposure control in the Creative Zone modes:

- Program AE (P) mode allows the photographer to use the program shift feature.
- Shutter-priority (Tv) mode allows the photographer to control the shutter speed.
- Aperture-priority (Av) mode allows the photographer to control the aperture.
- Automatic Depth-of-field AE (A-DEP) mode allows the photographer to use exposure compensation and white balance control.
- Manual (M) mode allows the photographer to control both shutter speed and aperture.

In the Basic Zone modes, exposure is automatically determined by the camera. Full Auto is the Digital Rebel's "snapshot" automatic mode, and the PIC (Programmed Image Control) modes are used for fully automatic shooting in specific situations:

Full Auto
Portrait
Landscape
Close-Up
Sports
Night Portrait
Flash Off

Exposure Compensation is available up to +/-2 stops in 1/3 stop increments in any of the Basic Zone modes, plus you can also choose AEB (auto exposure bracketing). When in the Creative Zone modes, you can use AE (autoexposure) lock when the camera is shooting in One-Shot AF mode (see page 130). AE lock is enabled with the AE lock button (found just below the Mode Dial on the back right-hand side of the camera). AE lock cannot be used in any of the Basic Zone modes.

White Balance Controls

The Digital Rebel offers several choices for white balance settings. The first is automatic white balance, or AWB (the camera chooses). Then there are a group of preset white balances that match specific conditions: daylight (balanced for mid-day sunlight), shade (matches light from open blue sky), overcast (cloudy days), tungsten (indoors with incandescent lights) and fluorescent (fluorescent lights). Last is manual, or custom, white balance, which can be set from reading a gray or white card.

The Shutter

This camera features a vertical-travel, mechanical, focal-plane shutter with all speeds electronically controlled. Shutter speeds range from 30 to 1/4000 second (set in 1/3 stop increments), plus bulb. Flash X sync is 1/200 second or slower. The shutter release is a soft-touch electromagnetic release.

The camera has only one setting for the self-timer, giving a ten-second delay. You can also trip the shutter remotely with a dedicated electronic cable release or a wireless remote control.

Processing Parameters

The Digital Rebel offers a rather unique way of dealing with in-camera controls that can adjust contrast, color, and sharpness – internal processing parameters. In addition to three preset parameters (Parameter 1, Parameter 2, Adobe RGB), up to three additional custom parameters can be set (Set 1, Set 2, Set 3). Utilizing the preset parameters, or creating your own, can help you to achieve the most desirable look for your photos, whether it be bright and punchy or soft and subdued. (See page 57-58 for more detailed descriptions of the processing parameters.)

The Built-in Flash

The camera comes with a built-in flash that pops up from the top of the camera, above the lens, in front of the viewfinder eyepiece. It activates automatically in most Basic Zone modes and can be manually opened as needed in user controlled modes. In optimal conditions at ISO 100 the built-in flash has a range of approximately 2.3 - 12 feet (.7 - 3.7 meters). It recycles in approximately three seconds, and will cover up to an 18mm focal length (equivalent to approximately 28mm in 35mm format). The Digital Rebel also accepts EOS-dedicated EX Speedlite accessory flash units for full E-TTL autoflash exposure.

Drive System

While technically a digital camera does not have film or a motor drive, the camera does move through photos as if it did have a motor drive. The Digital Rebel has two main drive modes (excluding the self-timer/remote control mode): single-image and continuous, which are selected automatically in certain shooting modes. Continuous shooting speed is approximately 2.5 fps (at 1/250 second or faster) with a maximum burst of four shots during continuous shooting. (Burst is how many shots can be fired before the internal buffer is filled. The camera then stops shooting until these images are recorded to the memory card and removed from the buffer).

LCD Monitor

On the back of the Digital Rebel is a 1.8-inch (about 4.6 cm) color LCD monitor of approximately 118,000 pixels. The coverage of the actual image file (when reviewed) is close to 100%. If you need to adjust the brightness of the LCD monitor, you can do this through setup menu one ᵠᵀ1 . Use the directional cross keys ✥ to scroll down to the LCD brightness option, then press ⒮ᴇᵀ . There are five different brightness levels to choose from.

Use the playback button ▶ *to review images on the LCD monitor.*

Images will play back on the monitor in five ways:

- a single image – press the playback button ▶ _
- a single image with a histogram and exposure data – press the info button INFO. while in playback
- a nine-image index display – press the index button ▦ while in playback
- an enlarged image – press the enlarge button ⊕ while in playback
- Auto Play (a simple slideshow) – selected through the playback menu

When using the info button INFO. during image playback, overexposed highlight areas with no information will blink to alert you that they have no detail.

Photos can be quickly erased after shooting by playing them back on the LCD monitor and using the the erase button 🗑 . Photos can also be protected from erasure as needed. (See page 182 for more details.)

LCD Panel

Not to be confused with the LCD monitor, this small black and gray panel sits above the monitor and is always operational when the camera is on. It displays information on camera settings, including exposure and white balance. It can be illuminated in dark conditions by pressing the LCD panel illumination button (indicated by a light bulb icon ☀) just to the right of the panel.

1. Shutter speed
 Busy
 Date/time battery
 Level warning
 ISO speed
 Camera starting (EOS)
2. AF point selection
 CF card full warning
 CF card error warning
 Error code
 Cleaning image sensor
3. Aperture value
4. Shots remaining
5. ISO speed
6. Red-eye reduction

7. Beeper
8. Drive Mode
 Single
 Continuous
 Self-timer/Remote control
9. Image-recording quality
10. Exposure level indicator
 Exposure compensation
 amount
 AEB level
 CF card writing status
11. Battery level
12. AEB
13. White balance selection

Playback menu
Shooting menu
Set-up 1 menu
Set-up 2 menu
Tab

Quality	Large
Red-eye on/off	Off
AEB	-2..1..☼..1..2+
WB-BKT	. . . ☲ . . .
Beep	On
Custom WB	
Parameters	Parameter 1

Menu items **Menu settings**

Menus

Most of the controls on the Digital Rebel are buttons or dials, which are readily accessible on the camera body. However, there are several important camera functions that must be accessed through the camera's four internal menus: the shooting menu ◘ , the playback menu ▶ , setup menu one ⚙1 , and setup menu two ⚙1 . These can be displayed on the LCD monitor by pushing the menu button MENU (located in the upper left-hand corner on the back of the camera).

Note: Menus can be set to many languages: English, German, French, Dutch, Danish, Finnish, Italian, Norwegian, Swedish, Spanish, Chinese (simplified), and Japanese.

Battery Power

A single BP-511 or BP-512 lithium ion rechargeable battery (produced by Canon as well as other manufacturers) powers the Digital Rebel. An optional power grip (BG-E1) adds an extra battery for longer life. The camera can also be plugged in to AC power with the optional Canon AC adapter kit (ACK-EZ).

Power usage by the camera is highly dependent on how often different features of the camera are used, such as autofocus, the LCD monitor, and the flash. Canon estimates that

The less you use the flash and the LCD monitor, the longer your battery will last.

at 68° F (20° C), the battery will last approximately 600 frames without flash, or about 400 when the built-in flash is used 50% of the time. Lower temperatures will reduce the number of shots. In addition, it is never wise to expose your camera or its accessories to heat or direct sunlight (i.e., don't leave the camera sitting in your car on a hot day, or a cold one!).

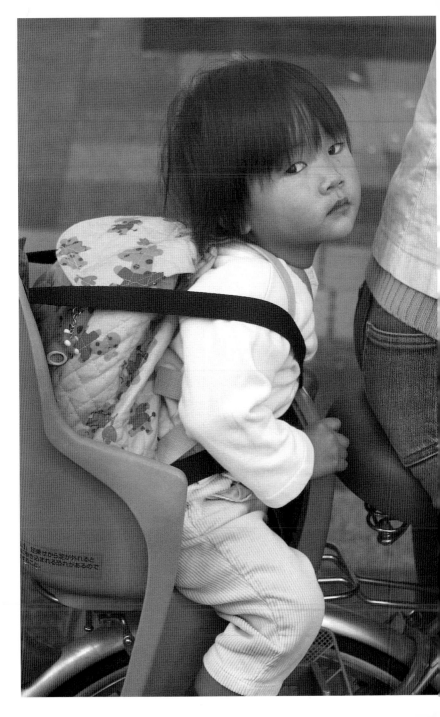

Quick Start Shooting Guide

The Digital Rebel is designed to operate like a traditional film camera and has many features in common with other Canon EOS SLRs. This section includes a quick overview of the camera's features for those who want to get started taking pictures. Before using the camera, be sure to attach the camera strap and adjust it to fit your body. Double check that the strap is securely attached to the camera to help prevent an accidental drop.

Use the Protect option to be sure not to erase images you want to keep.

1. *Insert the CF Card:* The Digital Rebel takes a standard Type
 I or II CompactFlash (CF) memory card. It should be
 inserted before turning the camera on. (While damage to a
 card is rare, when it is inserted after the camera is turned
 on, it can happen.) First, locate the CF card slot cover on
 the right side of the camera. You can access the slot by
 gently pulling the cover back (towards the rear of the cam-
 era). Once the cover is open, take your CF card and insert
 the edge with the contact holes into the slot (the CF card's
 manufacturer label should be facing the back of the cam-
 era). You will feel some tension between the card and the
 slot when it is most of the way in. Gently press the base of
 the card all the way into the slot, and you will see the
 black CF card eject button (just below the card) pop up. To
 remove the card, be sure that the camera is switched off,
 then simply press the CF card eject button back down and
 the memory card will pop out of the slot.

 Caution: Do not ever force the card into the slot. You may
 damage the card, the camera, or both.

2. *Powering Up:* This may sound really basic, but it is a fairly
 common mistake: Be sure your battery is well-charged
 before using the camera. If the camera is used with a low
 battery and you take a picture, there is a possibility that the
 camera will be recording the image to the memory card as
 the battery quits. This can damage the memory card.

 To insert the battery, carefully turn the camera upside
 down until you see the battery compartment cover on
 the bottom of the camera body. While supporting the
 camera with one hand, slide the battery compartment
 release lever in the direction of the arrow that is
 impressed below the words "BATT. OPEN" on the cam-
 era body. Once the cover is open, insert the battery,
 contacts first, until it locks into place. Press the cover
 closed until you hear it click shut. (To remove the bat-
 tery, follow the same instructions for opening the bat-
 tery compartment cover, then slide the battery lock
 lever in the direction shown by the arrow.)

Turn the camera on by rotating the Power switch on the top right of the camera to the ON position. Each time you do this, take a look at the battery power indicator on the LCD panel to be sure it is charged. The camera automatically shuts off after one minute to conserve power (a default setting that may be adjusted), but will activate again when you lightly touch the shutter button.

3. *Format the CF Card:* It is necessary to format your CF card to work with your camera before you can start taking pictures. Start by pressing MENU, then use the directional cross keys ✛ to select the first setup menu ᵧ🕈1. Now scroll down to the Format option and press ⑤ɛᴛ. The options "Cancel" and "OK" will appear; select "OK" and press ⑤ɛᴛ again. When the CF card formatting is complete, setup menu one ᵧ🕈1 will reappear. (See page 55 for more detail.)

 Caution: *If the card you are going to format has pictures on it, they will be erased by this process. Make sure to download them or save them to CD before you format.*

4. *Changing Lenses:* One of the great advantages of the Digital Rebel over point-and-zoom style digital cameras is that its lenses can be interchanged. However, whenever a lens is off the camera, there is a potential for dust to get into the camera body and settle onto the sensor. You can help prevent this by never leaving the camera without a mounted lens or body cap, and when you change lenses, do it carefully but quickly. Also, when a lens is not mounted on the camera, make sure that you attach the front and rear lens caps to keep dust off of the lens elements. Many photographers turn the camera off to change lenses in order to minimize any static charge that might build up on the sensor or lens contacts that could attract dust or damage the camera.

 To attach the lens, hold it securely by the grooved section closest to its rear. Mount it to the camera by aligning the white (or red) raised indicator on the lens with

*Align the colored indi-
cator on the lens with
the index mark on the
camera's bayonet
mount.*

the white (or red) index mark on the camera's bayonet
mount. Turn the lens in a clockwise direction until it
clicks into place. You can check to see that it is firmly
locked by gently trying to turn it in a counter-clockwise
direction. The lens is removed by pressing the lens
release button and turning it in a counter-clockwise
direction. Always change lenses with the camera strap
safely around your neck or shoulder, and the camera
switched to the OFF position.

Note: The EF-S 18-55mm f/3.5-5.6 lens that comes with
the Digital Rebel prepackaged kit uses white markings,
but all other Canon lenses usable with this camera use
red markings.

5. *Controls:* The Digital Rebel has a very intuitive set of
 controls. Most of them are clearly labeled, and if you
 are not sure of a control, you can push or rotate it and
 typically see a change on the LCD panel (not the LCD
 monitor). In addition to the buttons and dials on the
 camera, there are control functions inside the four inter-
 nal menus.

6. *Menus:* There are four menus, activated by pressing the
 MENU button on the back left of the camera. Once you
 have accessed the main menu screen, you can scroll
 back and forth between the menus by using the left and
 right-hand directional cross keys ✥ to highlight the
 desired menu. Inside each menu, several options are

listed. You can select a particular option by using the up and down cross keys to highlight the option, then hitting the set button ⑯ (located in the middle of the cross keys). This will give you a new set of choices related to the selected menu option, and here again you will use the four directional cross keys ✧ and the ⑯ button to choose the desired action.

The first menu is for camera functions, the second is for playback, and the last two are used for important camera setup controls such as auto power off and format.

Note: The "Clear all camera settings" option in setup menu two will bring all camera controls back to their original default settings.

7. *Info:* The INFO. button allows you to accesses important information about your pictures. When pressed during playback, it causes the LCD monitor to show details about the photograph, such as a histogram and exposure data. (See page 180 for more about the INFO. button.)

Select autofocus or manual focus using the focus mode switch found on the lens.

8. *Focus:* Autofocus (AF) and manual focus (MF – see page 124-133) are selected on the lens, not on the camera body. When the lens is set to AF, the camera will autofocus when you lightly depress the shutter button. Hold it down halfway, and the focus will lock as long as the subject is not moving In P, Tv, Av and M modes, the camera automatically selects between

One-Shot focus and continuous focus when it senses movement. In Full Auto and most of the PIC modes, One-Shot focus is always used. (See page 124-133 for more about focusing.)

9. *Exposure:* The Digital Rebel does an excellent job with evaluative metering in all automatic modes. You can always double check exposure using the histogram (see page 73) when you review the image on the LCD monitor (the histogram is a better indication of exposure than the picture's appearance alone). If you find that the camera is overexposing or underexposing your shot, you can use exposure compensation (detailed on page 103) to adjust the exposure to your satisfaction.

10. *Downloading Images:* Many beginners to digital photography think that, because it is seemingly encouraged by the camera box and manual, the best way to download digital images is to use the camera and the USB connections that come with the camera. In reality, this is awkward and often slow. Plus, it means dealing with power issues. If the battery loses power while you are making the transfer from CF card to computer, the memory card may be damaged and you could lose your pictures. So, often AC power is better than a battery.

The easiest way to transfer images to your computer is by using a card reader. Card readers are inexpensive and simple to use and they take up very little space on your desktop. They can remain connected to the USB port on the computer so that they are always ready to transfer images.

11. *Erasing Images:* You can quickly and easily erase images with your camera by pressing the erase button 🗑 when the image is visible on the LCD monitor. You can do this directly after the picture has been taken if image review is turned on (in the playback menu ▶ under Review). You can also display images using the playback button ▶ . Once you see the image, you can press

the erase button 🗑 to delete it (located at the bottom left of the camera back). If you are in the instant review mode (directly after the picture has been taken), you will see the word "Erase" with the options "Cancel" or "OK." To erase, move the selection to "OK" with the cross keys ✥ and press ⑤ET .

If you are in playback mode you have the option to erase the whole card with one command. When you press the erase button 🗑 , you get a slightly different message: "Cancel," "Erase," and "All." "Cancel" is the default selection, so you have to deliberately decide to erase images. If you select "Erase," you will only delete the photo you see on the screen. "All" takes you to another message: "Erase all images?" and "Cancel" or "OK." This screen is your last chance to cancel the erase all option. (More on page 178.)

12. *Protecting Images:* You have the option of protecting those photos that you want to be sure not to erase. This way if you use the erase all option, you will only erase unprotected photos. (Keep in mind, however, that for-matting your CF card will erase all information, even protected images.) To protect a photo, press MENU and use the cross keys ✥ to enter the playback menu ▶ . Then, scroll down to the Protect option and press ⑤ET . You will be able to scroll through your images and select which ones to protect. Just press ⑤ET again when an image you wish to protect appears onscreen. If you press ⑤ET yet another time, you can cancel that image's protection. (See page 184 for further detail.)

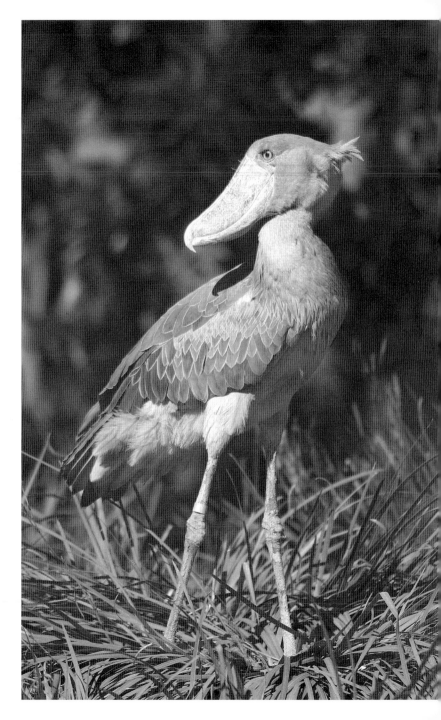

Image Exposure & Processing

Resolution & Quality Settings

Most of the time, you will want to keep your Digital Rebel at its highest resolution and quality settings (JPEG or RAW). At 6 megapixels (3072 x 2048 total pixels), the camera offers very high-quality images. You can easily make prints 11x14 inches (27.9 x 35.5 cm) or smaller that are as good as anything possible with 35mm film. With practice, you may even be able to get 16 x 20-inch prints (40.6 x 50.8 cm) from this camera that rival film.

The camera offers seven resolution and quality options (set in the shooting menu ◘ from a series of resolution and quality pairings). These are grouped by image size and JPEG compression, plus RAW (see page 18-20 for an explanation of JPEG and RAW files). While an approximate file size for an image saved with JPEG compression can be given, this is only approximate, since JPEG is a variable compression format. Varied scenes will compress differently, plus ISO speed and parameter settings also affect compression. (For this reason, the camera is unable to display with certainty the number of shots remaining on the CF card. The number given is only an approximation, unlike with frame counters on traditional film cameras.)

The first two settings are at the full (Large) image size of 3072 x 2048, and differ only in the JPEG compression–either Fine (low compression) or Normal (moderate compression). The Large/Fine resolution setting results in a file of approximately 3.1 MB, while Large/Normal turns out to be about 1.8 MB. Large/Fine offers excellent quality that is very

⟲ *Use the Digital Rebel's Large/Fine resolution setting if you plan to make an enlargement of your image.*

close to RAW, but at a much smaller file size. Large/Normal drops slightly in quality but more images can be put on a memory card. With today's high-capacity memory cards, Large/Fine is probably the best choice for most people.

The next setting is Medium at 2048 x 1360 pixels. This is about 2.8 megapixels. There is a slight advantage to speed in using this (the file size is smaller), but unless you really only want a 2.8 megapixel image, there seems little point in using it, regardless of the compression used (Fine compression yields an image with a file size of about 1.8 MB; Normal results in about 1.2 MB.).

If you really need a small file size to maximize the number of pictures that will fit on your memory card, or you only need low-resolution image files (such as those used for web site work), you are probably better off skipping the Medium settings and going to Small. This is an approximately 1.6 megapixel image size. Files drop to 1.4 MB in Fine and 0.9 MB for Normal. If small file size is crucial, you may find that Small/Normal is the best choice, keeping in mind that you sacrifice print quality.

RAW is at the bottom of the Quality menu (located in the shooting menu 🖸) and offers full resolution using the RAW file and its 12-bit image capture. (Interestingly, Canon also embeds a JPEG file within the RAW file that can be extracted using their software). Canon's proprietary RAW file is called a CRW file and, unlike a JPEG image, this file must be processed using specific computer software before it can be read by most image-editing programs. (Locate the File Viewer Utility software that came with your camera. In addition, several other manufacturers have created software that may have features not found on the software Canon provides. Just make sure that any software you invest in is compatible with the Digital Rebel!)

Canon's File Viewer Utility software is easy to use, though it doesn't offer some of the features available in other RAW processing software. Even so, it does a very

good job of translating details from the RAW file into TIFF or JPEG form. Once converted, the new TIFF or JPEG files are readable by any image-processing program. TIFF is the preferred file format (JPEG would only be used if you had file space limitations).

The big advantage to the RAW file is that it captures more directly what the sensor sees. It holds more information (12-bits vs. the standard 8-bits per color) and can have stronger correction applied to it (compared to JPEG images) without problems showing. This can be particularly helpful when there are difficulties with exposure or color balance.

Note: RAW files are about 7 MB in size, so they will fill memory cards quite quickly. In addition, they can increase processing and workflow times.

Formatting the CF Card

Caution: Formatting will erase all images and information stored on the card, including protected images. Be sure that you do not need anything on the card to be saved before you format! (If necessary, transfer important images to a computer before formatting the card.)

Before you use a CF card in your camera, it should be formatted specifically for the Digital Rebel. In other words, if the card has been formatted on another camera, you should reformat it. To format your card, press MENU, then use the directional cross keys ✛ to select the first setup menu ⚙1. Now scroll down to the Format option and press (SET) . The options "Cancel" and "OK" will appear; select "OK" and press (SET) again. When the CF card formatting is complete, setup menu one ⚙1 will reappear.

Reformatting your CF card is a good choice to make at least once in a while to clean up your memory card and keep its data structure organized. Never format the card in a computer as they use different file structures than digital cameras—this

can make the card unreadable for the camera. Keep in mind that card formatting will erase all of the images on the card, whether they were previously protected or not!

Processing JPEG Files

Canon cameras do offer an advantage to using JPEG files that isn't necessarily self-evident. While it is true that a RAW file offers a wider range of image data to work with, the Digital Rebel includes a unique processing chip—the DIGIC Imaging Processor—that processes the raw sensor data for you before recording it as a JPEG file. This is a rather smart translation, which will mean for many photographers that there is little difference between high-quality JPEG and RAW files.

Note: It is important to differentiate between raw sensor data and RAW files. "Raw" is the word used by the digital photography industry to describe the data from the sensor that is used to create files. RAW is a format, whereas "raw" refers to the actual data coming from the sensor.

The DIGIC Imaging Processor was developed by Canon exclusively for Canon products. The Digital Rebel uses a DIGIC Imaging Processor identical to the ones used in other EOS digital cameras. It uses some very sophisticated algorithms to bring out image detail, improve gradation in highlight areas (which has traditionally been a problem for digital cameras), and enhance the translation of color data so that color reproduction is more natural. It is also interesting to note that the DIGIC chip actually improves the camera's battery performance, and makes the camera even more responsive than it would be otherwise.

RAW files are still important for challenging photography where you may need to make extensive image corrections, and also for when you need high-resolution image files (RAW files enlarge better than a JPEG image). Many photographers who shot digital photos using RAW files in the days

before the DIGIC chip may not be aware of its power. How-
ever, to get the most from it, you do need to be sure your
exposure and white balance are properly set.

Processing Light & Color

The Digital Rebel has some unique settings that control how
the camera reacts to light and color. In some ways, these are
like having different film types ready to use as needed just
by changing the settings on the camera. They tell the camera
how to process the image that the sensor captures.

There are three preset processing parameters (Parameter 1,
Parameter 2, and Adobe RGB) plus three that can be custom
set (Set 1, Set 2, and Set 3) all of which are accessible through
the shooting menu 📷 under the parameters option. Each
one will affect the contrast, sharpness, saturation and color
tone on a scale of -2 to +2. In other words, zero is the "nor-
mal" setting, and sliding the scale to the left or the right of
zero effectively adds or subtracts from these specified aspects
of your photo. (In the case of color tone, the left side of the
scale, -1 and -2, brings out more red in the photo and the
right side of the scale, +1 and +2, brings out more yellow.)
The scales in the three preset parameters are set to provide
specific effects, while the three custom settings allow you to
create your own variations of these effects.

Note: The camera must be in the P, Tv, Av, M or A-DEP set-
tings in order to use these parameters.

• Parameter 1 is the standard, default camera setting.
 Canon refers to it as, "vivid and crisp." It increases con-
 trast, sharpness and saturation by one step. This is the set-
 ting to use if you prefer to print your images directly from
 the camera (with brighter tones and colors) without going
 through the computer.

• Parameter 2 has all image options set to 0 so, in essence, this
 is actually the base setting even though it is not the default

camera choice. Parameter 2 will not boost color or contrast but, ideally, it offers more control over the image on the computer, and may be useful for more sophisticated users.

- Parameter 3 is based on the color space Adobe RGB, a space well known to Photoshop users. It is geared toward people who understand and specifically want to work in that color space. For the average photographer, Parameter 1 and Parameter 2 are much more useful. Adobe RGB does offer a large color space to work with while in Photoshop, but photographers not accustomed to using Photoshop will probably find that their images appear dull. For this reason, I don't recommend using the Adobe RGB parameter unless you are an experienced Photoshop user.

None of these choices are absolute. You may find that you prefer the snappier color and sharpness of Parameter 1 even if you do like working in Photoshop. You may discover that you use Parameter 1 in low contrast situations, such as fog, to increase the clarity of the image. Parameter 2, which has lower contrast to begin with, could detract from such a scene. You may also find that Parameter 1 makes subtle colors too harsh in portrait situations, rendering skin tones unrealistic. Here, perhaps, Parameter 2 would better serve you. Test your subjects and your way of working to see which parameter best suits your specific photographic needs.

You also have the option of setting up three of your own parameters. This is essentially like being able to formulate your own film. You can do this by choosing the Set Up option at the end of the Parameters menu (found in the shooting menu 📷). In each custom parameter setting (Set 1, Set 2, and Set 3), you can adjust contrast, sharpness, saturation, and color tone to suit your preferences.

Think about how you might use these. For example, you could create one custom parameter set for skin tone (portraits) by increasing the red tones. Simply adjust the color tone balance to the left of center using the directional cross keys ✛ . Then you could decrease both sharpness and contrast a bit

In this hazy landscape shot, increasing contrast and sharpness helped to accentuate the finer details of the photo.

(adjusting balance to the left of center) to create a softer look. And increasing color saturation slightly (adjusting balance to the right of center) would brighten skin color. Or, to set a custom parameter for landscapes, you might increase contrast, sharpness and saturation (leaving color tone in the middle) to add detail and vibrancy to outdoor scenes.

Once you have created these custom parameters, you can go to them whenever you want. This gives you more control over your photographs as you are shooting. You can even alternate between different parameter options as you go. For example, use Parameter 1 for a landscape hazy with early morning fog, change to Parameter 2 for a colorful scene in bright sun at midday, then select a custom setting for an indoor portrait. This is like having a whole set of films at your disposal, all at the push of a few buttons. With the parameter settings, you will gain a great deal of control over how your subject is captured from the start, which will make any computer editing work easier later on. In addition, the parameters will help to optimize your prints on the camera itself if you prefer to go directly from CF card to print.

Metering System

As soon as you depress the Digital Rebel's shutter button, a sophisticated metering system is engaged. This system is designed to give consistently good exposures. 'Perfect' is an elusive goal, and only you can decide if you have a perfect exposure. The better you know the system, the better you will be able to make adjustments and get the most from the camera.

One thing to remember is that the Digital Rebel's meter, on a basic level, will act just like every other meter—with a bias to make a scene average in tone. It senses the light and offers an exposure to turn what it sees to middle gray in tone, regardless of how dark or bright it is. Meters will make dark objects too light (to make them gray) and light things too dark (again, to make them gray). To get around this, camera manufacturers have created complex metering systems that rely on more than one point for metering a scene.

Evaluative metering is Canon's proprietary system. The EOS Digital Rebel's Through-the-Lens (or TTL) metering system takes 35 different measurements of the light coming into the camera as focused by the lens from a particular scene. In addition, the camera evaluates and compares all 35 metering zones across the image. These zones come from a grid of 5x7 metering areas that cover most of the frame, except the edges.

As with all Canon EOS cameras, the Digital Rebel's evaluative metering system is linked to the autofocus. The camera actually notes where the active autofocus point is and emphasizes the corresponding metering zones in its evaluation of the overall exposure. If the system detects a significant difference between the main point of focus and the different areas that surround that point, the camera automatically applies some exposure compensation (it assumes the scene includes a backlit or spot-lit subject). However, if the area around the focus point is very bright or dark, the metering can be thrown off and the camera may underexpose or overexpose the image. Luckily, you can check exposure information on the

LCD panel, or check the image itself on the LCD monitor, and make adjustments as needed (explained below).

Some photographers prefer to do their own metering of a scene and have their own way of evaluating the readings. If this appeals to you, the Digital Rebel allows for two additional types of metering that are specific to which mode you are shooting in.

Partial metering is set automatically during AE lock in the Creative Zone modes. It limits exposure readings to a small area in the center of the viewfinder (approximately 9%). Partial metering acts like spot metering when a telephoto lens is used on the camera. This allows the photographer to selectively meter small parts of a scene and compare the readings in order to select the right overall exposure. This can be an extremely accurate way of metering, but it does require some practice to do well.

Center-weighted metering is set automatically in M mode, and uses most of the image area for metering, strongly emphasizing the center part of the horizontal frame. Some photographers have used center-weighted metering for a long time and know it so well that they prefer keeping with it. It can be very useful with scenes that have a lot of very light or dark areas around the subject.

Note: The other types of metering are not available in M mode.

Since you can see how well the metering system is doing by examining the LCD monitor and histogram, you can quickly make a judgment on the exposure and change it if needed. With this information, you have a great deal of control with automatic exposure—more than many photographers realize.

First, exposures in the automatic Creative Zone settings (P, Tv, Av and A-DEP) can be tweaked with exposure compensation. On the Digital Rebel, this shows up on a little scale on the LCD panel and in the viewfinder. You push the Av+/-

button on the back of the camera and turn the Main Dial (found just behind the shutter button) to increase or decrease exposure by 1/3 f/stops (see page 103 for more about exposure compensation).

You can also lock autoexposure on specific objects in a scene. You can do this in two ways: either hold down the shutter button halfway, or push the ✳ button (AE lock) at the top right of the of the camera back. The advantage of using the second autoexposure lock is that only exposure is locked (the first will also lock autofocus). Plus, you can't accidentally set off the camera if your finger isn't on the shutter button! The ✳ button is very easy to use with your thumb (keep in mind that this will also set the metering to partial).

To experiment with AE lock, point the camera at grass that is in the same light as your subject and press the ✳ button. This locks the exposure on the midtone grass, which will give a good exposure. The exposure will stay locked for about six seconds, or as long as you hold the ✳ button down. You can lengthen your exposure time by pointing the camera at something dark, then pushing the ✳ button (the meter wants to make the dark area brighter to reach middle gray, so it lengthens the exposure). You can also do the opposite by pointing the camera at something bright before pushing the button. By watching the exposure change in the viewfinder, you can actually control exposure quite well this way (and much faster than using any other technique).

One thing to be careful about with exposure and this camera is the viewfinder eyepiece. This may seem odd, yet if you have the camera on a tripod and you do not have your eye to the eyepiece, there is a good possibility that your photo will be greatly underexposed. The Digital Rebel's metering system is very sensitive to light coming through an open eyepiece. To prevent this, you should remove the eyecup and slide the eyepiece cover (located on the camera strap) over the opening in these conditions. If you can't access your eyepiece cover for whatever reason, you can cover the eyepiece any way that works, but you do need to

If the camera is on a tripod and not up against your eye, be sure to cover up the viewfinder eyepiece in bright outdoor situations to ensure that your camera's metering system is unaffected by extraneous light.

cover it if the light is bright. You can quickly check the effect by watching the LCD panel as you cover and uncover the eyepiece—you'll see if the exposure changes.

Natural Light

Digital camera technology has paved an easy road for natural light photographers. By using white balance and ISO settings, the photographer can shoot in an amazing, varying range of light and still get consistent color from one ISO setting to another.

Color casts can usually be eliminated by matching the white balance setting (see page 119-123) to the type of light source. Color and light in nearly any scene can be made to look natural by using the custom white balance setting. You can even adjust the camera so that it records scenes in hues that are warmer or

cooler than a purely neutral rendition would be. Sometimes a scene doesn't look right if colors have no color cast. Good examples of this point are sunrise and sunset. The light is quite warm then, so a neutral balanced image might look unrealistic. This is one reason why the automatic white balance setting will sometimes give unacceptable results.

Many subjects, such as people in portraits, look their best in warm light. Warming filters remain very popular with film for this reason (cooling filters are also available, but aren't used as much). You get the same effect without filters by setting a white balance that is designed to correct a light that is cooler than the actual lighting of your scene. For example, try using the cloudy/twilight/sunset setting on a bright sunny day. Experiment and check your results on the LCD monitor.

Judging Exposure

The LCD monitor on the back of the camera allows you to check your photo's exposure—it's just like using a Polaroid, except this is truly instant and there is no waste. With a little practice, you can use this to determine your desired exposure, but realize that it only gives an indication of what you will actually see when the images are downloaded into your computer (because of the monitor's size and resolution).

Experiment with exposure and white balance settings to optimize ⇨
picture quality in varied lighting situations.

Generally, photos like this are most successful when underexposed because both contrast and saturation are increased. While a photo can always be adjusted in the computer, it is ideal to start with the best possible camera exposure. (©Jeff Wignall).

Above: Use a higher f/number (smaller aperture) to accentuate depth of field.

Below: The Close-Up PIC mode is perfect for shots such as this.

67

Use the LCD monitor to check for image clarity.

Above: It is best to use a custom white balance setting when you wish to capture the warm colors of sunset.

Below: A polarizing filter was used to increase the color saturation of the blue sky and yellow flowers in this photo.

Telephoto lenses are often the best choice for wildlife photographers because their limited depth of field isolates the subject from its surroundings.

In Close-Up mode ❀ , try different shooting angles. Just a slight ▷ *adjustment in camera position will often change the background in the photograph from light to dark or one color to another. One of these will likely show off the subject better than the others.*

The Digital Rebel includes two features that give you a very good indication of whether or not each exposure is correct. These features are the highlight alert and the histogram. They are accessed by pushing the INFO. button (located just below the MENU button on the left side of the camera back) after a photo is displayed in the LCD monitor. (To display a photo, press the playback button ▶ found just below the JUMP button on the left side of the camera back.)

Highlight Alert

The camera's highlight alert is very straightforward: overexposed highlight areas will blink. These areas have so much exposure that only white is recorded, no detail. This isn't necessarily bad. Some scenes have less important areas that will get washed out if the most important parts of the scene are exposed correctly. However, if you discover that significant parts of your subject are blinking, the image is likely overexposed. You need to reduce exposure in some way.

The Histogram

The Digital Rebel's histogram is small, but worth understanding. It is the graph that appears on the LCD monitor when the info button INFO. is pressed during playback, indicating the image's brightness. It will also appear automatically when the camera's image review is set to Review [On (info)]. The horizontal axis indicates the level of brightness—dark areas will be weighted to the left, bright areas will be weighted to the right. The vertical axis indicates the pixel quantity existing for the different levels of brightness. If the graph rises as a slope from the bottom left

Take your Digital Rebel with you on your travels to capture unique scenes such as this Dutch street art. (© Haley Pritchard).

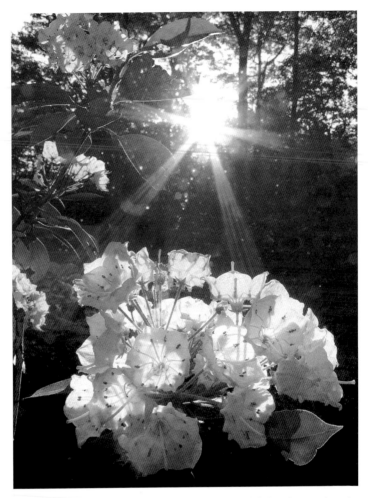

Pay careful attention to the Digital Rebel's highlight alert system to help avoid potential overexposure.

corner of the histogram, then descends towards the bottom right corner, all the tones of the scene are captured. If the graph starts out too far up on either side of the histogram so that the "slope" looks like it is cut off, then the camera is cutting off data from those areas (it may have to if the

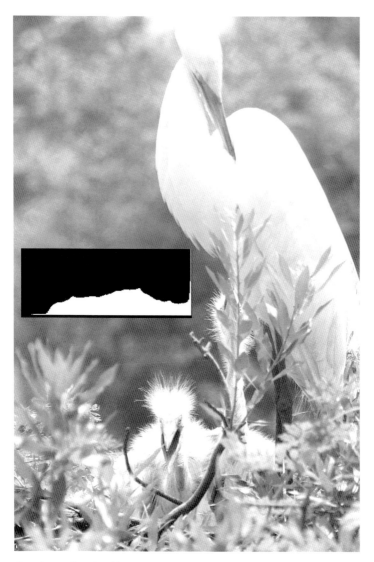

As shown by the histogram, weighted to the right, this image is overexposed, meaning that detail has been lost in the bright parts of the photo.

This photo is underexposed, as depicted by the histogram weighted to the left. Detail in the dark areas of the photo has been lost.

contrast range is beyond the capabilities of the camera—a darkly shadowed subject on a bright, sunny day for example). When the histogram is weighted towards either the dark or bright side of the graph, detail may be lost—dark sections of your photo may fade to black, and brighter sections may appear completely washed out.

If highlights are important, be sure that the slope on the right reaches the bottom of the graph before it hits the right side. If darker areas are important, be sure the slope on the left reaches the bottom before it hits the left side. You don't actually have to remember which side is dark or light at first. Just give the scene a change of exposure and notice which way the histogram changes. This is a really good way to learn to read the histogram.

Some scenes are naturally dark or light. In these cases, most of the graph can be on the left or right, respectively. However, be careful of dark scenes that have all the data in

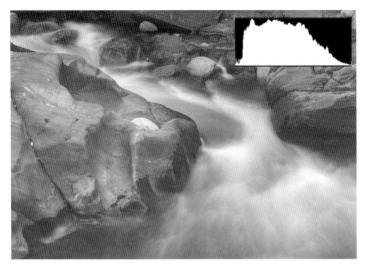

By increasing exposure, the same scene is captured with much greater detail and clarity, seen on the histogram as a more even distribution of pixels.

the left half of the histogram. Such underexposure tends to overemphasize any sensor noise that might be present. You are better off increasing the exposure, even if the LCD image looks bright enough. You can always darken the image in the computer, which will not affect grain, yet lightening a very dark image usually will have an adverse effect and result in added noise.

If the scene is low in contrast and the histogram is a rather narrow hill in the middle of the graph area, check the Digital Rebel's parameter settings. Parameter 1 will boost contrast (expanding the histogram), and you can create a custom setting to go even farther. This can mean better information being captured since it is spread out more evenly across the tones before even using image-editing software.

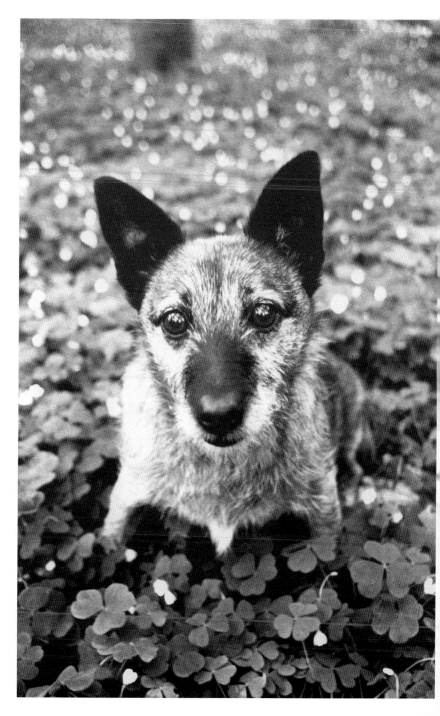

Power Needs & Camera Care

Power

The power needs of the Digital Rebel are simple—it takes a single lithium-ion rechargeable battery (Canon BP-511 or BP-512). This is the basic battery used by most of Canon's digital SLRs and larger compact digital cameras (such as the G-series). There are independent brands of these batteries available, but be sure you check its fit before using it (occasionally independent batteries are too snug in the battery compartment, so save the packaging and receipt!).

The battery should last quite awhile, though this will vary depending on how often you use certain camera functions. The camera uses the most power to focus, capture images, record photos to the memory card, and display them on the LCD monitor. The more the camera is on and active, the shorter the battery life, especially with regard to LCD monitor use. One way of getting more battery life from your camera is to purchase Canon's optional battery grip, BG-E1. This unit holds two batteries, essentially doubling your shooting time. (It is always a good idea to shut the camera off if you are not using it).

Auto Power Off

The camera has an auto power off function with a default setting of one minute. You may find this frustrating if you go to take a picture and find that the camera has shut down. For

↶ *Be sure to take care of the power needs of your camera so you will never miss an opportunity when you head out for a day of shooting pictures. (© Haley Pritchard).*

Adjust the auto power off timing to suit particular photographic situations so that the camera is always ready to take a picture when you are.

example, you might be shooting a soccer game and the action stays away from you for a couple of minutes. If auto power off is at one minute, the camera will be off as the players move toward you. Now you try to shoot and nothing happens as the camera is powering back up. You may miss the shot. In this case, you might want to change the setting to four or eight minutes so that the camera stays on when you need it to.

You can decide how long the camera stays on by setting the auto power off function yourself. Access setup menu one **↑↑1** by pressing MENU and scrolling over to it using the directional cross keys **✛** . Auto power off will be the first option in this menu. Press ⬚ when you have highlighted it, and you will be given choices ranging from one minute to 30 minutes (including an "Off" option that will prevent the camera from turning off automatically). When you have selected one of these choices, press ⬚ again, and then MENU to exit the menu.

Battery power can be a significant issue when traveling. You don't want to pull off the highway to photograph a scenic view only to find that your battery is dead. For these occasions, it may be wise to purchase the optional car battery cable kit (CR-560). The charger plugs directly into your car lighter and can charge two batteries at once (one battery takes about an hour and a half to charge). The optional AC adapter (ACK-E2) can also be useful for those who need the camera to remain consistently powered up (i.e. for scientific lab work).

Cleaning the Camera

It is important to keep your camera clean in order to minimize the amount of dirt or dust that could reach the sensor. A good kit of cleaning materials would include the following: a soft camel hair brush to clean off the camera, an anti-static brush and micro-fiber cloth for cleaning the lens, a pack towel for drying the camera in damp conditions (available at outdoor stores), and a small rubber blower to blow off debris from the lens and the camera (you can get these from a camera store, or use a baby's ear-syringe or an enema bulb—they both work very well).

Always blow and brush debris from the camera before rubbing with any cloth. For lens cleaning, blow and brush first, then clean with a micro-fiber cloth. If you find there is residue on the lens that is hard to remove, you can use a lens cleaning fluid (be sure it is made for camera lenses). Never apply the fluid directly to the lens, as it can seep behind the lens elements and get inside the body of the lens. Apply with a cotton swab, or just spray the edge of your micro-fiber cloth. Rub gently to clean it, then buff the lens with a dry part of the cloth. Keep your cloth in its protective packet to keep it clean—you can wash it in the washing machine (and dry it in the dryer) when it gets dirty.

You don't need to be obsessive about cleaning your camera. Just remember that a clean camera and lens helps to

Keeping the camera body and lens free of dust and dirt will help to minimize the risk of image problems, like the dust spots in this photo.

ensure that you don't have image problems. Dirt and other residue on the camera can get inside when changing lenses, risking build-up on the sensor. Dust will show up as small, dark, out-of-focus spots in the photo (most noticeable in light areas, such as sky). You can minimize problems with sensor dust if you turn the camera off when changing lenses (that keeps static charge from building up), as well as by keeping a lens or body cap on the camera at all times.

The Digital Rebel does allow you to clean the sensor, but there are precautions to be taken. You must do this carefully and gently, indoors and out of the wind. Your battery must be fully-charged so it doesn't fail during cleaning (or you can use the AC adapter). The sensor is very sensitive and if the gentle cleaning described below doesn't work, you should take the camera into a Canon Service Center for cleaning.

To clean the sensor, turn the camera on and go to the second setup menu **↑↑2** . Scroll down until Sensor clean is highlighted, then press ⟨SET⟩ . You will get a new screen that reminds you to turn the camera off when done. Select OK. The mirror will lock up and the shutter will open. On the LCD panel, you'll see a blinking "Clean." Take the lens off. Then, holding the camera face down, use a blower to gently blow any dust or other debris off the sensor. Do not use brushes or compressed air as these can damage the sensor's surface.

Note: Canon specifically recommends against any cleaning techniques or devices that touch the surface of the imaging sensor.

Be sure to switch the camera off after cleaning the sensor.

Holding the camera body up, with the open front facing down, will help prevent the dust and debris from falling back onto the sensor. When you are done, turn the camera off. This will make the shutter and mirror go back to their regular positions. Put the lens (or the body cap) back on the camera. You can now turn it on again for shooting.

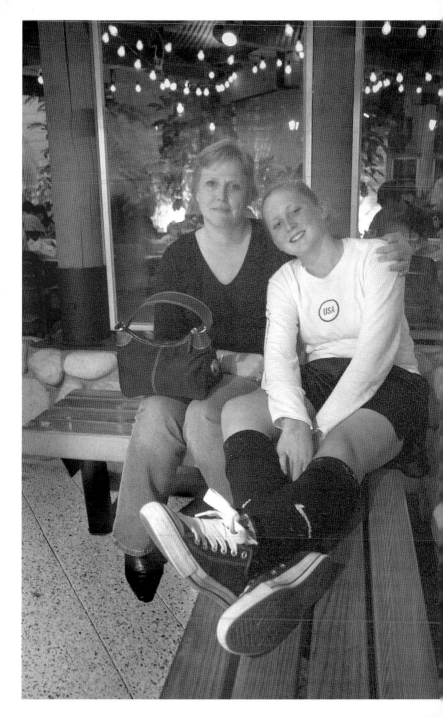

The Basic Zone

The Basic Zone is home to the Programmed Image Control modes and includes Full Auto. Find Full Auto ☐ on the Mode Dial, and note that the settings counter-clockwise from it are the PIC modes. These specialized PIC modes—Portrait, Landscape, Close-Up, Sports, Night Scene, and Flash Off—are identified by various picture icons. The built-in flash will pop up and fire automatically in all Basic Zone modes other than Landscape, Sports, and Flash Off modes.

Full Auto Mode

Full Auto ☐ is a basic setting indicated by the green box on the Mode Dial. As Canon describes this mode, "everything is automatic so it is easy to photograph any subject." Since little can be adjusted with this setting, it is great for the beginning photographer, perfect for quick grab shots, and a good choice to use when someone else is taking a picture for you. However, as you get more experience with the camera you will find that many subjects require more than a quick shot.

In Full Auto mode, the thirty-five-zone evaluative metering system helps to ensure accurate exposure, especially in fairly normal shooting conditions. The camera is in AI Focus mode, and the camera activates One-Shot AF unless the subject starts to move. If subject movement is detected, the camera automatically switches to AI Servo AF (see page 128-132 for more about focusing and drive mode selection). The shutter will fire only after focus is achieved—you will see the focus confirmation light ● in the lower right-hand corner of the viewfinder and hear the focus confirmation beeper, if it is on. If needed, the built-in flash will automatically pop up.

Night Portrait mode blends flash and existing light to create a more natural-looking picture.

Programmed Image Control (PIC) Modes

The PIC modes tailor the camera's settings to the specific requirements of certain types of photography. These modes are a little like Full Auto in that you can't change much yourself. However, you may find that these convenient modes fit some of your particular situational needs. ISO and white balance settings are automatically selected by the camera. Autofocus point selection is also chosen by the camera, and all exposures are based on evaluative metering. These modes aren't for everyone, yet they do offer an excellent way to quickly prepare the camera for a specific subject.

Portrait Mode

The Portrait mode is designed to select a large aperture (lower f/stop number) so that depth of field is limited. This creates an out-of-focus background so that the focused subject stands out against it. This desirable portrait effect is more pronounced when you use a telephoto lens and when the background is not close behind the subject. In Portrait mode, the camera automatically sets itself to One-Shot autofocus with continuous shooting (meaning the camera fires repeatedly as long as you hold down the shutter button and the internal buffer is not full). The flash will pop up automatically if the camera thinks you need the light (even if you don't!). This can be helpful outdoors when a bit of fill flash may be useful to balance out sharper contrast areas.

Landscape Mode

Next on the dial is the Landscape mode. It is designed to set the camera to a small aperture (higher f/stop number) so that you will get more depth of field. This is useful for scenic photography where you want to get as much of the scene in focus as possible. In this mode, the camera uses One-Shot AF and single-frame shooting. The flash is turned off. You can certainly use this mode for more than landscapes— cityscapes, group photos, and travel scenes also work well with it. Be aware that Landscape mode may set slow shutter speeds in low light conditions, so you will need to brace the camera using a tripod or other support. This mode works

In this photo, which includes both a foreground subject and an extensive background scene, it is best to choose A-DEP mode over Landscape mode. A-DEP will assure that the camera's microprocessor maximizes depth of field.

well for scenic shots, but if you want to put a subject in the foreground of your picture—such as family members in front of the Alamo or a lighthouse in Maine—you should switch to the A-DEP (Automatic Depth-of-field AE) mode. This mode will help to ensure that both the people in the foreground and the background scenery are acceptably sharp. (See page 101 for more about A-DEP mode.)

Close-Up Mode 🌷

Designed for taking photos at close-focusing distances, the Close-Up mode utilizes thirty-five-zone evaluative metering in order to achieve optimal exposure of every detail. The built-in flash pops up automatically if ambient light is too low to produce good exposure. This mode automatically selects One-Shot AF and single-frame film advance. These are chosen because close-up work usually involves static subjects and often requires careful composition for every frame. The flash is set to automatic, so it will come on when the camera thinks it should.

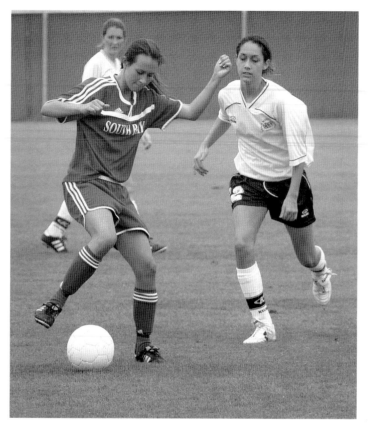

Sports mode favors a fast shutter speed, freezing action and eliminating blur in pictures of wildlife and sporting events.

Sports Mode 🏃

The Sports Mode is designed for fast action, which makes it useful for wildlife or kid photography as well as sports. It favors high shutter speeds, keeps the flash off, and uses evaluative metering. The purpose of this program mode is to render the sharpest possible images of moving subjects. Thus, fast shutter speeds are given priority. At brighter light levels, the program selects progressively faster shutter speeds in order to stop action, while simultaneously reducing the

aperture size to optimize depth of field. The program will reduce the aperture even further when the maximum hand-held shutter speed has been reached. This type of exposure control is particularly effective with telephoto lenses.

A key feature of this mode is the way it uses autofocus. The camera first focuses on the subject using the center AF point, but then it tracks the focus on the subject as it moves through the frame, using all of the seven AF points as needed. If you continue to hold down the shutter button, the camera will continue to track focus on the subject as it shoots pictures. It does this by computing the location of the subject and predicting where it will be when the next image is shot. Obviously, there are limits to this. The Digital Rebel is a fine camera, but it is not a high-end sports camera, so a fast moving subject can beat the autofocus at times. One way to help the camera is to start autofocusing before you need to take the shot. In other words, hold the shutter button down halfway as the action develops so that the camera is ready when you need to take the actual photo. For best results, practice using this technique before attempting it at an important event.

Night Portrait Mode

Night Portrait is a neat mode that makes it easy to combine flash and existing light. With flash in low-light conditions (such as dawn or dusk), the light often ends up looking very harsh in the photograph, with bright light on the subject and everything in the background pitch black. With this mode, the camera actually blends two light sources in one shot by creating two exposures simultaneously—one exposure based on the flash and a second based on the existing light of the scene. This allows detail in the area behind the subject to show up, resulting in a more natural-looking picture. This is probably most useful for photographing people against sun-sets or lighted tourist attractions at night. The subjects in the foreground should not move during the exposure since, if they do and there are lights in the background, they may look like ghosts in the photo with the background lights showing through them.

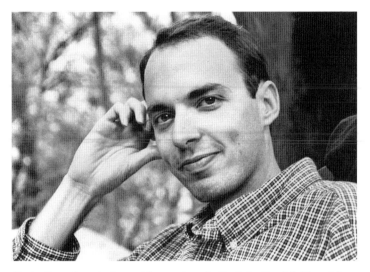

Portrait mode selects a wide aperture to limit depth of field and thus emphasize the subject. (© Haley Pritchard).

In this mode the camera will typically select a very slow shutter speed. This can result in a blurred background where the flash has had no effect, as well as blurred edges around the subject either from subject or camera movement after the flash has gone off. The Digital Rebel manual rightly recommends using a tripod for optimum sharpness. However, you don't always need one. If the background is greatly out of focus, additional blur from camera movement won't affect it much. Plus, shooting so that sharp detail contrasts with blurry movement can be quite interesting. With your digital camera, you can see the effect without having to wait for film processing.

Flash Off Mode

The last of the PIC modes is Flash Off. This mode totally automates keeping the flash turned off, which can be very helpful for beginners who don't yet feel comfortable working in the Creative Zone. This mode is especially helpful in places like a museum where flash photography is not allowed.

Portrait mode is not just for people. Shooting statues and details with this mode often leads to interesting results. (© Jeff Wignall)

The Creative Zone

The Creative Zone is for the photographer who wants more control over the elements of his or her picture. Modes in this zone, found clockwise from Full Auto ☐ on the Mode Dial, are P (Program), Tv (Shutter-priority), Av (Aperture-priority), M (Manual exposure), and A-DEP (automatic depth-of-field). Keeping the photographer informed, the camera provides important exposure information on the LCD panel and in the viewfinder display. The Creative Zone modes warn of overexposure or underexposure by the blinking of the shutter speed, aperture, or both. All of the Creative Zone modes use AI Focus, with the exception of A-DEP mode, which uses One-Shot AF. The Creative Zone modes also give complete control over the camera's built-in flash (it will not fire unless you pop it up manually with the flash button, located just left of the built-in flash).

Program AE Mode (P)

Selected by turning the Mode Dial to P, this mode allows for program shift. This means that you can change the aperture and shutter speed combination (the program) that the camera has selected and still maintain the same exposure value. To shift the program, simply press the shutter button halfway, then turn the Main Dial (located just behind the shutter button) until the desired shutter speed or aperture value is displayed (look in the viewfinder display or at the LCD panel). Although this only works for one exposure, it does increase the versatility of this mode, making it useful for quick-and-

Use flash and a slow shutter speed to create a unique sense of motion, as in this vibrant hand-held shot. (© Haley Pritchard).

Program AE can be a great mode for quick-grab shots, and can be shifted in shutter speed or f/stop.

easy shooting while retaining some control over camera settings. Also note, however, that you cannot use program shift if you are using flash.

Program AE mode selects shutter speed and aperture values "steplessly." This means that any shutter speed or aperture within the range of the camera and lens can be selected, not just those that are the standard full steps, such as 1/250 second or f/16. For this reason, you may see unfamiliar numbers, such as 160 (1/160) and f/13, appearing on the information displays. Not to worry. Stepless shutter speed and aperture combinations allow for extremely precise exposure accuracy, thanks to the EF lens' electromagnetically controlled diaphragm and the camera's electronically timed shutter.

If the system determines that there is risk of a bad exposure, the shutter speed and aperture values will blink in the viewfinder. If this occurs because there is too much light, a neutral-density (ND) or polarizing filter can be used to

Use a tripod and a slow shutter speed to create an image that juxtaposes creative blur effect with sharply rendered motionless areas of the photo.

reduce the amount of light coming into the lens. You can also decrease the ISO setting. If there is insufficient light, either increase the ISO speed or try using a larger aperture (smaller f/number).

Shutter-Priority Mode (Tv)

Tv (which stands for "time value") signifies shutter-priority autoexposure. Shutter-priority means that you set the shutter speed and the camera sets the aperture. If you want a particular shutter speed for artistic reasons—perhaps a high speed to stop action or a slow speed for blur effect—this is the setting to use. In this mode, even if the light varies, the shutter speed will not. The camera will keep up with changing light by adjusting the aperture automatically. If the aperture indicated in the viewfinder or LCD panel is consistently lit (not blinking), evaluative metering has picked a useable aperture. If the maximum aperture (lowest number)

blinks, it means the photo will be underexposed and you need to select a slower shutter speed by turning the Main Dial (behind the shutter button) until the aperture indicator stops blinking. You can also remedy this by increasing the ISO speed. If the minimum aperture (highest number) is blinking, this indicates overexposure. In this case, you should set a faster shutter speed until the blinking stops, or choose a slower ISO speed.

Aperture-Priority Mode (Av)

When you select Av (aperture value) on the Mode Dial, you are in Aperture-priority mode. In this autoexposure mode, you set the aperture (the f/stop or lens opening) and the camera selects the proper shutter speed for a good exposure. This is probably the most popular automatic setting among professional photographers.

Controlling depth of field is one of the most common reasons for using Aperture-priority mode. The f/stop, or aperture, refers to the amount of light allowed to enter the camera and has a direct effect on depth of field. A small lens opening (higher f/number) such as f/11 or f/16 will increase the depth of field in the photograph, bringing objects in the distance into sharp focus. Higher f/numbers are great for landscape photography. A wide lens opening such as f/2.8 or f/4 will decrease the depth of field. These lower f/numbers work well for taking sharp portraits.

You can see the effect of the aperture setting on the image by pushing the depth-of-field preview button on the camera (located just below the lens release button). This will stop the camera down to the taking f/stop (the lens otherwise remains wide-open until the next picture is taken). Using depth-of-field preview takes some practice, as the viewfinder will get darker, but changes in focus can be seen if you look hard enough. You can also just check focus in the LCD monitor after the shot, as digital allows you to both review and/or delete your photos as you go.

Use Av mode to select a lens opening and the Digital Rebel will automatically determine the shutter speed appropriate for that aperture.

A sports or wildlife photographer might choose Av mode in order to stop action rather than for depth of field. To accomplish this, he or she selects a wide lens opening—perhaps f/2.8 or f/4—adjusting the aperture to let in the maximum amount of light. In Av mode, the camera will then automatically select the fastest shutter speeds. With Tv mode, while you can set a fast shutter speed, the camera still may not be able to expose correctly if the light drops and the selected shutter speed requires a larger lens opening than the particular lens can provide (you will see the aperture blink in the viewfinder in such a case). So typically photographers will select Tv only when they have to have a specific shutter speed. Otherwise they use Av for both depth of field and to gain the highest possible shutter speed for the conditions.

Manual exposure mode allows for ultimate control over exposure, giving you the freedom to experiment with different combinations of aperture and shutter-speed settings to achieve the best possible look for your image. (© Haley Pritchard).

Manual Exposure Mode (M)

This Manual exposure option is important for photographers who are used to working in full manual (although I would suggest trying the automatic settings at times to see what they can do—remember, you can't waste film by trying), and also for anyone who faces certain tricky situations. In Manual exposure mode, you set both the shutter speed and aperture yourself. You can either use the exposure meter of the camera, which will be center-weighted (exposure is visible on the scale at the bottom of the viewfinder display—"correct" exposure is at the mid-point), or use a hand-held meter.

⟡ *Use Aperture-Priority mode for scenic photography to ensure adequate depth of field. (© Jeff Wignall).*

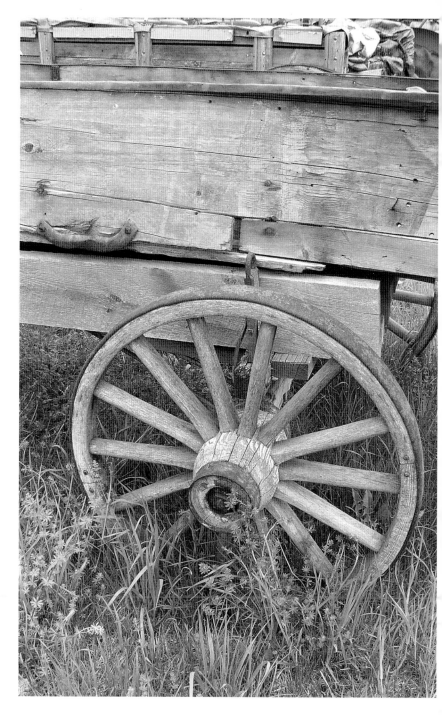

The following are examples of some of the tricky metering conditions that might require you to use M mode: panoramic shooting (you need a consistent exposure across the multiple shots taken, and the only way to ensure that is with manual), lighting conditions that change rapidly around a subject with consistent light (a theatrical stage, for example), close-up photography where the subject is in one light but slight movement of the camera dramatically changes the light behind it, and any conditions where you need a consistent exposure.

Automatic Depth-of-Field AE Mode (A-DEP)

The last controllable exposure mode is A-DEP. It allows the photographer to quickly gain sharpness in the depth of the photo. In this mode, the camera actually looks at all seven autofocus points and compares them. It then tries to select an f/stop and focus point that will give depth-of-field coverage based on what the AF points detect as the closest and farthest distances in the composition. For that reason, it does not work in manual focus. In addition, you cannot change f/stops or shutter speeds—the camera does it all—though you can use exposure compensation and white balance controls. This mode often sets slow shutter speeds, so you must be prepared to put the camera on a tripod or other support.

If you notice blinking numbers in the viewfinder in A-DEP mode, the camera is trying to tell you something. If the aperture number blinks, it means the camera can set a good exposure, but it cannot get enough depth of field for the subject. If the shutter speed number 30″ blinks, it means the ISO needs to be increased. If the shutter speed number 4000 blinks, it means the ISO needs to be decreased.

↰ *Program mode is ideal for a day of enjoyable shooting while on vacation. (© Jeff Wignall).*

Image Control

The Digital Rebel may be designated a "non-professional" digital SLR, but don't let that fool you. It does offer many excellent features. By understanding how these features work and how to use them effectively, you can gain a lot of image control from this camera.

Exposure Compensation

The combination of exposure compensation and LCD review means you can quickly get good exposures without going to M (manual) mode. Traditional photographers who have not yet discovered the advantages of autoexposure can benefit from understanding how and why to use exposure compensation. It cannot be used in Manual exposure, Full Auto, or any of the PIC modes. However, it makes the P, Tv and Av modes much more versatile.

It only works if the camera is active (i.e., you see both shutter speed and aperture in the viewfinder). Simply press the shutter button halfway to turn on the metering system (with camera on, of course). Then press the Av button (located just right of the LCD panel) and rotate the Main Dial to change the exposure compensation. You will see the exact exposure compensation on the scale at the bottom of the viewfinder display, as well as on the LCD panel on the back of the camera. Compensation is added (for brighter exposure) or subtracted (for darker exposure) by 1/3 f/stop increments.

When shadow plays a role in your composition, use exposure compensation to ensure that the shadowed parts of your image are not underexposed.

Large dark areas can make a meter give a scene too much exposure, so decrease exposure in such situations to compensate.

It is important to remember that once you set exposure compensation, it stays set even if you shut off the camera. Check your exposure setting (by looking at the bottom of the viewfinder display) as a regular habit when you turn on your camera to be sure the compensation is not inadvertently set for a scene that doesn't need it. With experience, you will find that you use exposure compensation routinely with certain subjects. Remember, the meter wants to increase exposure on dark subjects and decrease exposure on light subjects to make them closer to middle gray. For this reason exposure compensation may be necessary. For example, say you are photographing a kids' soccer game with the sun behind the players. The camera wants to underexpose here in reaction to the bright sunlight, but the shaded sides of the team members may be too dark, so you add exposure with the exposure compensation feature. Or maybe the game is in front of a densely shaded grove of trees. In this case the players would be overexposed because the camera wants to

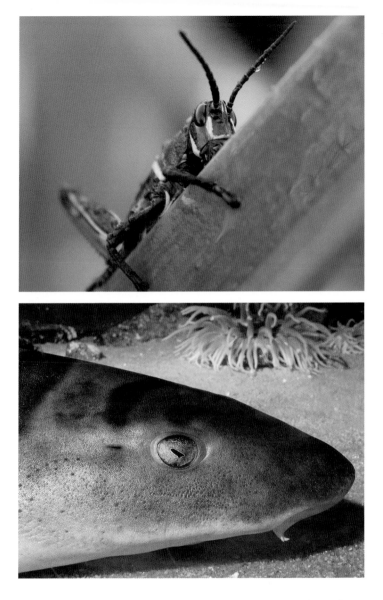

Above: Both color contrast and sharpness contrast have been employed in this close-focus picture.

Below: Fill flash can come in handy in any situation where the subject of the photo is backlit.

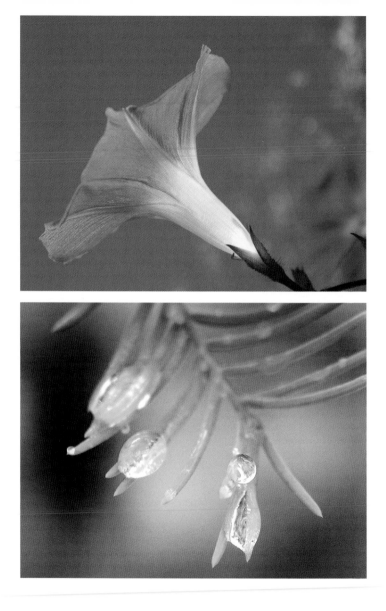

Close-focusing photos usually involve static subjects and require careful composition. For these reasons, Close-Up mode automatically selects One-Shot AF and single-frame film advance.

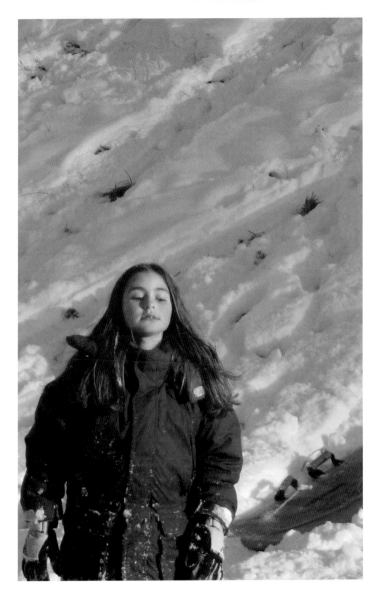

The white balance setting for tungsten bulb ❄ *will add a blue tone to snowy scenes. (© Kevin Kopp).*

Take multiple shots of the same scene using different white balance settings to see which one results in the best color for your image.

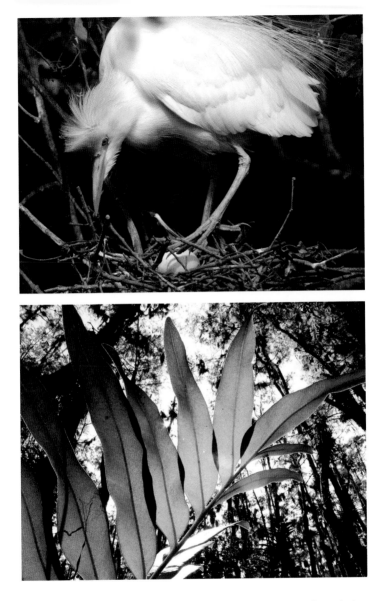

Above: Be sure to use a tripod or other camera support when photographing at focal lengths of 300mm or more.

Below: The creative play of light and shadow often results in uniquely appealing photos.

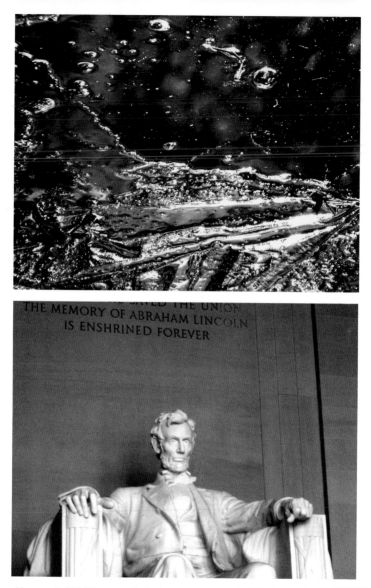

Above: A UV filter can help to protect the front of your lens when photographing outdoors. (© Bill Costello).

Below: It is fun to take photos from different perspectives. Because of the size of the Lincoln statue, this shot is from below. (© Kevin Kopp).

Even on a bright, sunny day you may use flash to fill in and reveal dark areas of your subject.

Above: Use the Main Dial to adjust exposure compensation in situations like this where the subject may be underexposed due to bright light in other areas of the photo.

Below: Use the depth-of-field preview button to ensure that you are shooting at the optimal aperture setting for your scenic shots, like this one from Antietam National Battlefield. (© Kevin Kopp).

react to the dark trees. Here, you subtract exposure. In both cases, the camera will consistently maintain the exposure you have selected until you readjust the exposure settings.

The LCD monitor can come in very handy when experimenting with exposure compensation. Take a test shot, then check the photo and its histogram. If it looks good, go with it. If the scene is too bright, you should subtract exposure, if it's too dark, you should add it. Again, remember that if you no longer want to use exposure compensation, you must deactivate it!

Autoexposure Bracketing (AEB)

The Digital Rebel also offers another way of applying exposure compensation – autoexposure bracketing (AEB). AEB can be set through the shooting menu ◘ and tells the camera to make three consecutive exposures that are different: a standard exposure, one with less exposure, and one with more. The difference between exposures can be set up to +/- 2 stops in 1/3 stop increments. If you use AEB, remember that the camera will continue to take three different exposures in a row until you turn the control off. (It is also canceled when you turn the camera off or change lenses.)

AEB can help ensure that you get the best possible image files for later adjustment using image-editing software. A dark original file always has the potential for increased noise as it is adjusted, and a light image may lose important detail in the highlights. AEB can help you to determine the best exposure for the situation. You won't use it all the time, but it can be very useful when the light in the scene is especially varying in contrast or complex in its dark and light values.

AEB is also important for a special digital editing technique that allows you to put multiple exposures together into one master to gain more tonal range from a scene. You can take the well-exposed highlights of one exposure and combine them with the better detailed shadows of another. If

*In tricky lighting situ-
ations, use autoexpo-
sure bracketing
(AEB) to give you a
choice of exposures.*

you shot these different exposures with your camera on a tri-
pod, they will line up exactly so that if you put the images
on top of one another as layers using image-editing software,
the different exposures are easy to combine. (You may even
want to set the camera to continuous shooting – in this
mode, it will take the three photos for the AEB sequence and
then stop.)

Shutter Speeds

The Digital Rebel offers a choice of speeds, from 1/4000
second up to 30 seconds in 1/3 stop increments, plus bulb.
For flash exposures, the camera will sync at 1/200 second or
slower (which is important to know since slower shutter
speeds can be used to pick up ambient or existing light in a
dimly-lit scene). Let's examine these shutter speeds by desig-
nating them "fast," "moderate," and "slow." (These divisions
are arbitrarily chosen, so speeds at either end of the divi-
sions can really be designated into the groups on either side
of them.)

Fast shutter speeds are 1/500-1/4000 second. It wasn't all
that long ago that most film cameras could only reach 1/1000
second, so having this range of high speeds on a low-priced
digital SLR is quite remarkable. The obvious reason to choose
these speeds is to stop action. The more the action increases
in pace, or the closer it crosses directly in front of you, the
higher the speed you will need. As mentioned previously, the

neat thing about a digital camera is that you can check your results immediately on the LCD monitor to see if the shutter speed has in fact frozen the action.

At these fast speeds, camera movement during exposure is rarely significant unless you try to handhold a super telephoto lens of 600mm (not recommended!). This means you can handhold most normal focal lengths (from wide-angle to tele-photo up to around 300mm) with few camera movement problems. Besides stopping action, another important use of the very high shutter speeds is to allow you to use your lens at its wider lens openings (such as f/2.8 or f/4) for selective focus effects (shallow depth of field). In bright sun, for example, you might have an exposure of 1/200 second at f/16 with an ISO setting of 200. To get to f/2.8, you have to go five whole steps of exposure to approximately 1/4000 second.

Moderate shutter speeds (1/60-1/250 second) work for most subjects and allow a reasonable range of f/stops to be used. They are the real workhorse shutter speeds, as long as there's no fast action. You do have to be careful when handholding cameras at the lower end of this range, especially with tele-photo lenses, or you may notice blur in your pictures due to camera shake during the exposure. Many photographers find that they cannot handhold a camera with moderate focal lengths (50-150mm) at shutter speeds less than 1/125 second without some degradation of the image due to camera move-ment. You can double-check your technique by taking a pho-tograph of a scene while handholding the camera, and then comparing the same scene shot using a tripod.

Slow shutter speeds (less than 1/30 second) require some-thing to stabilize the camera. Some photographers discover they can handhold a camera quite sharply at the high end of this range, with practice and when shooting with wide-angle lenses, but most photographers cannot get the most sharp-ness from their lenses at these speeds without a tripod or other stabilizing mount. Slow shutter speeds are used mainly for low light conditions and to allow the use of smaller f/stops (higher f/stop numbers) under all conditions.

Use slow shutter speeds to employ creative motion blur in your photos and check the effect on your LCD monitor.

A fun use of slow shutter speeds is to photograph move-ment, such as a waterfall or runners, or move the camera, such as panning it across a scene. The effects are quite unpredictable, but again, the LCD monitor review helps. You can try different shutter speeds and see what they look like. This is helpful when trying to choose a slow speed appropriate for the subject because each speed will blur action differently.

You can set long shutter speeds (up to 30 seconds) for special purposes such as capturing fireworks or moonlit landscapes. Canon has engineered the sensor and its accom-panying circuits to minimize noise (a common problem of long exposures with digital cameras) and the Digital Rebel does quite well with these exposures.

In contrast to long film exposures, long digital exposures are not susceptible to reciprocity. The reciprocity effect comes with film because as exposures lengthen beyond approxi-

mately 1 second (depending on the film), the sensitivity of the film declines, resulting in the need to increase exposure to compensate. A metered 30 second film exposure might actually require double or triple that time to achieve the effect that is actually desired. Digital cameras do not have this problem. A thirty second exposure is exactly that.

The bulb setting allows you to control long exposures (bulb comes after 30″ when scrolling through shutter speeds). With this option, the shutter stays open as long as you keep the shutter button depressed. Let go and the shutter closes. A dedicated remote switch, the Canon RS-60E3, is very helpful for these long exposures since it allows you to keep the shutter open without touching the camera (which can cause movement). You can use the infrared RC-5 remote switch for bulb exposures, as well.

Note: Dedicated remote switches are newer electronic versions of the cable release.

The camera will show the elapsed time for your exposure as long as you keep the remote switch depressed, which can be quite helpful in knowing your exposure. Canon claims that a fully charged battery will let you keep the shutter open for 2.5 hours. This may be technically true but, at this point in digital camera technology, exposures beyond two or three minutes start to have serious problems. Sensor noise builds up and starts to become noticeable, and the sensor itself starts to lose touch with the scene because small amplifiers near the sensor heat up during long exposures. This causes white, washed out areas to appear in the photo along the sides near where these amplifiers are located, making very long exposures unusable.

ISO

The Digital Rebel offers ISO (see page 16) sensitivity settings of 100-1600. The camera changes the sensitivity of the sensor to create a light sensitivity equivalent to film of the same

Change ISO or white balance settings from picture to picture by using the top or bottom directional cross keys and the Main Dial.

speed. (This change in sensitivity includes amplifying the electronic sensor data that creates the image, which can increase the appearance of noise.) High numbers mean that the Digital Rebel's sensor is more sensitive to light while low numbers mean it is less sensitive to light.

Traditionally, film would increase in grain and decrease in sharpness with increased ISO. This is not directly true with the Digital Rebel. Some increase in noise (the digital equivalent of grain) will be noticed as the higher settings are used, but it is minimal until the highest settings of 800 and 1600 are chosen. Little change in sharpness will be seen. Even the 800 and 1600 settings offer remarkable results, allowing you to shoot in much lower lighting conditions without using a flash. This opens up your photography to whole new possibilities of shooting with natural light and to using slower lenses (lenses with smaller maximum lens openings and usually physically smaller).

The low ISO settings give the least amount of noise (so low at ISO 100 that it can be difficult to find at all) and the best color. They are the settings to use most of the time in order to get optimum quality from your image files. For Full Auto mode and the PIC modes, you cannot change ISO and the camera will chose something between 100 and 400, depending on the mode and light level. Canon has made

changing ISO extremely easy. This is like being able to
change film whenever the conditions require it. The top
directional cross key ✧ is the ISO speed set button.
Press this top key and you'll go directly to ISO setting.
Then, turn the Main Dial (on the top of the camera behind
the shutter button) to change the ISO. You can see it chang-
ing on the LCD panel. When you have selected your
desired ISO, press the ISO button again, or press the shut-
ter button halfway and you'll be ready to shoot.

White Balance

White balance is one of the great new tools of digital cam-
eras. It means you can quickly and easily adapt your picture-
taking to different lighting conditions, from fluorescents to
daylight, capturing good color without filters.

Canon has really done it right with the Digital Rebel. For
a long time, camera manufacturers buried white balance in
menus. Most photographers didn't know they could make
changes and those that did found it inconvenient. The Digi-
tal Rebel makes white balance a key control that is easily
accessible (however, you can only change white balance in
the Creative Zone modes of P, Tv, Av, M and A-DEP).

The bottom of the directional cross keys ✧ is the white
balance button (WB). Push this bottom key and instantly the
camera is ready to change white balance. As with changing
the ISO, you rotate the Main Dial just behind the shutter
button to adjust your white balance. Watch the icons change
in the LCD panel until you get the one you want. Press the
white balance button again to select.

The Digital Rebel offers six preset white balance settings –
daylight, shade, cloudy/twilight/sunset, flash, white fluores-
cent light, and tungsten bulb. These can be chosen to match
specific lighting conditions or selected for the way they deal
with color for creative effect. In addition, there is an auto-
matic white balance setting (AWB) as well as a custom setting.

Automatic white balance **AWB** is either available or auto-matically selected in all camera modes. It examines the scene for you, interprets the light it sees, compares the conditions to what the engineers have determined works for such readings, and sets a white balance to make colors look neutral (i.e. whites appear pure, without color casts, and skin tones appear normal).

This can be a very useful setting when you are moving quickly from one light to another and whenever you hope to get neutral colors and need to shoot fast. Even if the setting isn't perfect, it will often get you close, so that only a little adjustment is needed later using your image-editing soft-ware. However, if you have time, you are often better off choosing from the rest of the camera's white balance settings because then you can be sure that the colors will be consis-tent from picture to picture (in AWB mode, they can vary as the camera readjusts for each shot).

The daylight setting ☀ adjusts the camera to make col-ors appear natural when shooting in sunlit situations between about 10 A.M. and 4 P.M. (middle of the day). At other times, when the sun is lower in the sky, it has more red light which will be seen as warmer when photographed using this setting. It makes indoor scenes under incandes-cent lights look very warm indeed.

The next setting is shade 🏠. Shadowed subjects paired with blue skies can end up very bluish in tone, so this setting warms up the light to make colors look natural, without any blue color cast (at least that's the ideal – individual situations will affect how well it cleans up that color). The shade setting is a good setting to use anytime you want to warm up a scene (especially when people are included), but you have to exper-iment to see how you like this creative use of the setting.

You might be inclined to think that the cloudy/twilight/ sunset setting 🌥 would provide greater white balance compensation than the shade setting, but the opposite is true. It does warm up cloudy scenes as if you had a warming

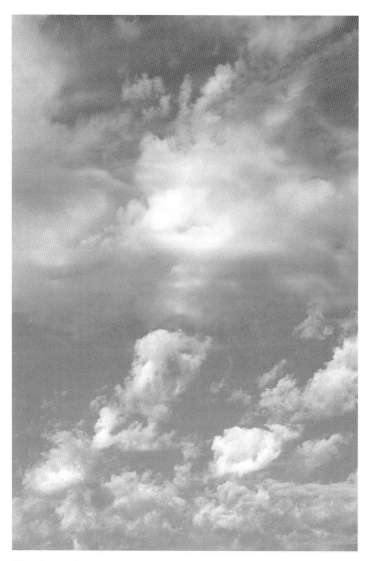

Use the daylight white balance setting to achieve a natural rendition of clouds in a sunlit sky.

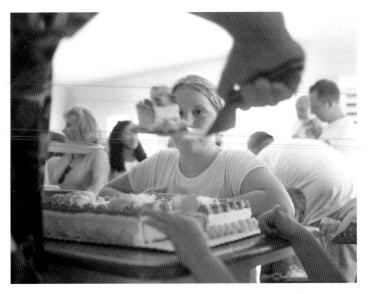

Try using the tungsten bulb or white fluorescent light settings to add colder or warmer tones to your indoor photographs.

filter, making sunlight appear warm, but not quite to the degree that the shade setting does. You may prefer the cloudy setting for people since the effect is not as strong. Both settings work well for sunrise and sunset, giving slightly warmer colors that we would expect to see in these photographs. However, the shade setting offers a slightly stronger effect. You really do have to experiment a bit when using these settings for creative effect. You may want to make the final comparisons on the computer.

The tungsten bulb setting ☀ reduces the strong orange color that is typical when photographing lamp-lit indoor scenes. It is also the best setting to use when photographing with quartz lights. Since this setting adds a cold tone to other conditions, it can also be used creatively for this purpose (to make a snow scene bluer, for example).

The AWB setting often works well with fluorescents but, under many conditions, the white fluorescent light setting ☀ is more precise and predictable. Fluorescent lights usually appear green in photographs, so this setting adds magenta to neutralize this effect. (Since fluorescents can be extremely variable, and since the Digital Rebel has only one fluorescent choice, you may find that precise color can only be achieved with the custom setting.) You can also use this setting creatively anytime you wish to add a pink tone to your photo (such as during sunrise or sunset).

Flash ⚡ tends to be a little colder than daylight, so this setting warms it up. I actually use it a lot, finding it a good all-around setting to use as it gives a slight, but attractive warm tone to outdoor scenes.

The custom setting ☀ lets you actually find something white (or gray) in a scene and have the camera white balance on it. This is a good thing to know because it can give remarkable results, but it is not as simple a setting choice as the other white balance settings on the Digital Rebel. First, take a picture of something white (or a known neutral tone) that is in the same light as your subject (try to center it in the frame). Then, in the shooting menu ▣ , choose Custom WB and push (SET) . It will ask you which photo to use, but the picture you just took should be there ready for you. Push (SET) again, then MENU to get out of the menus.

Next you go to the WB button (the bottom directional cross key ✛) and choose the custom icon ☀ . You have now created a new white balance setting that will stay associated with the custom choice until you repeat this procedure for a new subject.

Some people think that since the RAW format allows you to change things like white balance later on that choosing white balance when the photograph is taken is unimportant. Personally, I disagree. White balance choice is very important because when you bring a Canon RAW file into software for "translation," it comes in with the settings that you chose at

When you use white balance auto bracketing to take a photo, the camera will offer you three versions of the image, each with a different white balance setting.

the point of photography. Sure you can change it, but why not make a good image better with RAW by tweaking the white balance instead of starting from an image that requires major correction. There will be times that getting a good white balance setting is difficult, and this is really when the RAW software white balance correction can be a big help.

White Balance Auto Bracketing (WB-BKT)

If you do run into a situation where white balance is difficult, another option is white balance auto bracketing (which does not work with RAW). This is actually quite different than autoexposure bracketing. With the latter, three separate exposures are taken of a scene. With white balance bracketing, you take just one exposure, then the camera processes it to give you three different white balance choices.

You can access WB-BKT in the shooting menu 📷 . Based on the white balance setting you have chosen (the icon will blink to tell you white balance bracketing is being used), this function then adds and subtracts warmth to the image (you could also look at it as adding and subtracting cool tones). This bracketing is done up to +/- 3 steps (for the technically inclined, each step is equal to 5 MIREDs – microreciprocal-degrees – of a color correction filter). Keep in mind that even at the strongest settings, the color changes will be fairly subtle.

The obvious use of this feature is to deal with tricky lighting conditions. However, it has other uses as well. You may want a warm touch to a portrait, but are not sure how strong you want it. You could choose the cloudy setting 🌥 , for example, then use white balance bracketing to get the color right (the bracketing will give you the standard cloudy white balanced shot, plus versions warmer and cooler than that). Or, you may run into a situation where the light changes from one part of the image to another. Here, you can shoot the bracket then combine the white balance versions using an image-processing program (i.e. take the nicely white-balanced parts of one bracketed photograph and combine them with a different bracketed shot that has good white-balance in the areas that were lacking in the first photo).

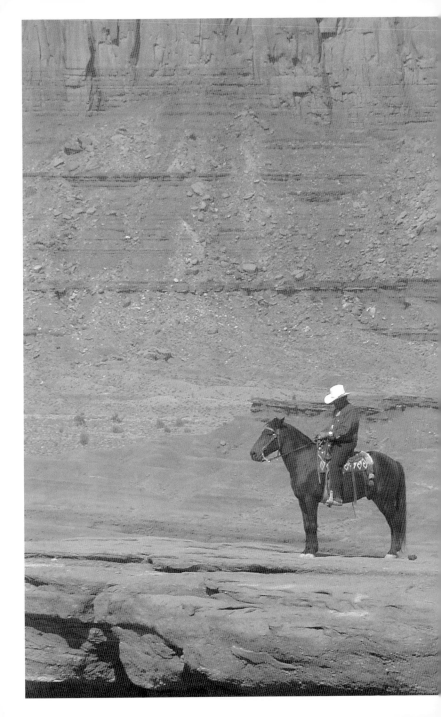

Focusing

Modern autofocus is very good, but it cannot guarantee correct focus for your subject. You have to use it wisely. For instance, it is important to engage the autofocus before shooting moving subjects. It can take a moment for the camera to lock focus on the subject before it is ready to take pictures. If you wait to focus right at the moment you are ready to take the shot, you may miss it.

You also need to be sure that the camera is focusing on the right portion of the image, not behind or in front of the subject. You can always check the LCD monitor to confirm this. Detail can be difficult to see on the small LCD screen, so you may want to zoom in on particular sections in order to examine them more closely.

The Digital Rebel uses an AI Focus AF system (artificial intelligence autofocus). This system allows it to automatically select from its two autofocus choices: One-Shot AF and AI Servo AF (both described below). When the camera uses One-Shot AF, it will lock focus on a non-moving subject and won't allow the shutter to be released if focus has not been achieved. AI Servo AF allows the autofocus to continually focus on a moving subject, and the shutter can be released any time, regardless of whether the subject is in focus or not (the focus will continuously catch up with the movement).

Make sure that the camera is selecting the appropriate AF point so that your subject will be rendered sharply in the finished photograph. If not, you can select the AF point manually or lock focus on the subject and recompose the photograph. (©Jeff Wignall).

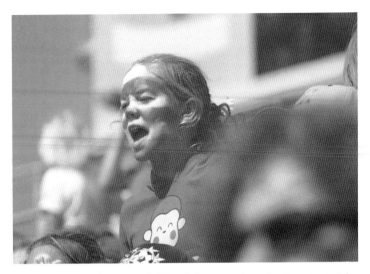

For this photo, the central AF point was automatically selected by the camera.

AF Points

The Digital Rebel uses a seven-point wide-area AF system based on a special CMOS (complementary metal-oxide semiconductor) sensor used just for autofocusing. "Wide-area" means it covers most of the viewfinder, so off-center compositions can be captured with autofocus. The seven AF points give the camera seven distinct spots where it can confirm focus (which for most subjects is plenty). They make a cross hair pattern of five horizontal points and three vertical ones (the center point is part of both).

You will see all of the AF points in the viewfinder so you know exactly where they are in relation to the subject. You can elect to have the camera choose the correct one to use or you can select it yourself. If the camera chooses, it examines all seven AF points to determine which point is seeing the closest part of the subject, but this can vary depending on how much "readable" detail the subject has (the camera

must be able to discern it). The nice thing about the Digital Rebel is that the AF point or points selected by the camera light up. You can tell immediately if it is selecting the best point for your composition.

If you find the camera is selecting the wrong part of the image, you have several choices. The quickest and easiest adjustment is to try to lock focus on the subject. Move the camera slightly so it favors the important part of your subject and lightly depress the shutter button until the correct point or points light up, then maintain this gentle pressure on the shutter as you move the camera back into the composition. The autofocus will stay locked as long as the subject is not moving. If you are using a zoom lens, you can often zoom into the subject, press the shutter button halfway to lock focus, then zoom out to your composition while still lightly holding the shutter button down (be aware that this will also lock exposure).

While the Digital Rebel does a very good job with autofocus, it won't match high-end pro cameras for autofocus speed. Partly, the speed of AF is dependent on the lens. The bigger the lens, the more mass it has to move internally, the slower the AF (more expensive lenses typically have faster motors). You can speed up autofocusing by holding down the shutter button halfway to get the camera to start focusing before you take the shot (or keep it on continuous shooting and start focusing before the peak of action so the camera can find and follow the focus on your subject). For moving subjects, the camera needs to start tracking focus before it can shift focus points in order to keep up with any changes in the subject's viewfinder position.

If you want to use autofocus and you know exactly where the subject will be (such as sliding in to the right side of second base in a baseball game), you can set a specific AF point to match your composition. This is pretty simple to do with the Digital Rebel and can be done with any of the seven points. First, press the AF point selector button ⊞ (found just below the Mode Dial at the top right of the back of the camera). Then look in the viewfinder or on the LCD

panel as you rotate the Main Dial (behind the shutter button). You will see the points change as one after another is selected individually. When you're done shooting with that specific AF point, remember to reset back to the original settings for autofocus or you may have trouble focusing with other subjects. To reset autofocus, press the AF point selector button again and rotate the Main Dial until you have scrolled all the way through the AF points and no one in particular is highlighted.

In really dark situations, the camera can use the built-in flash for an AF assist beam. You have to pop the flash up to do this if you are not in a mode that pops the flash up automatically. The flash will fire a brief burst of flashes when you press the shutter button halfway in order to help your camera autofocus. You do not have to use the flash for the picture. Once the flash fires the AF assist beam, keep the shutter button depressed to lock focus, then close the flash before taking the picture if flash has no part in the composition.

Drive Mode Selection

There are three different drive modes available for use with the Digital Rebel. These are all controlled by the drive mode selection button (located on top of the camera, just right of the Power switch). With the camera on, pushing the drive mode selection button will cycle through your three choices (their symbols show up on the LCD panel): single-image shooting ▢ , continuous shooting ⧉ and self-timer/remote control ⟳ᵢ .

Though some cameras allow for you to choose a focus mode when in these drive modes, the Digital Rebel chooses for you. The camera decides whether the subject is moving or not, though you can usually force it to focus using One-Shot AF by holding the camera very still on a stationary subject until the camera beeps (the focus confirmation light will be visible at the bottom right of the viewfinder). You can also force the camera into continuous focus by keeping the cam-

era on a moving subject or panning the camera across the scene. (Keep in mind that when the lens is set to AF and you are using a PIC exposure mode, the camera will be set in One-Shot AF for the Landscape, Portrait, and Close-Up modes, or continuous in Sports mode.)

Single-image shooting tells the camera to take one picture every time the shutter button is pushed and no more. With film cameras, photographers typically used single-image shooting because it only took one frame at a time and never wasted film on photos they didn't want. With digital photography, this is no longer necessary. If you hold the shutter button down and several photos are taken, no film is wasted. For this reason, you may prefer to use continuous shooting to get the shot you really want when the scene is changing (though you will have more photos to clean up later).

Continuous shooting with the Digital Rebel allows you to shoot photos at approximately 2.5 frames per second (this varies depending on the shutter speed), and will reach top continuous speed at shutter speeds of 1/250 second or faster). It will shoot up to four frames at a time before stopping to recycle power. The images captured by the sensor are put into a buffer inside the camera and then recorded to the memory card. Once the buffer is filled up, the camera stops taking pictures until more space becomes available (even if you are holding the shutter button down and the camera is set to continuous shooting). High-speed memory cards can help free up the buffer faster, though the increase in speed is not dramatic.

When trying to capture action, you will probably want to use continuous shooting. Remember not to start shooting too soon before the peak of the action—you might not have enough continuous shots available to start shooting too early. (The number—from zero to four—that appears in the viewfinder display just left of the focus confirmation light ● indicates the maximum number of continuous shots that can be taken.) Capturing gesture (people frequently change as they talk, smile, laugh, etc.) or photographing a continu-

ously moving scene (such as a crowd at a party) are examples of situations in which utilizing continuous shooting may be to your benefit.

Continuous shooting can help you to achieve sharper images with hand-held shooting at slower shutter speeds. (One of the major causes of camera shake is pressing the shutter button.) Often, when shutter speeds are low, one shot of a series taken using continuous shooting will be sharper than the others. Since you can't "waste" film with your Digital Rebel, continuous shooting can help to ensure that you get at least one good shot of the action you are trying to capture.

The **self-timer/remote control** drive mode on the Digital Rebel is very simple—when using the self-timer, the camera will take a photo ten seconds after you release the shutter. As the camera counts down the time until the picture is taken, you will hear a steady beep and the self-timer lamp (just left of the lens when looking at the front of the camera) will flash in rhythm with it. When only two seconds are left, the beep increases in tempo and the self-timer lamp stays lit. The time is also counted down on the LCD panel so you can see when the shutter button is about to go off. To cancel the self-timer after it has already begun its countdown, just press the drive mode selection button (directly left of the Power switch).

One obvious use of the self-timer is to include yourself in the composition. Be careful how you trigger the shutter when you do this. The camera will focus when the shutter is depressed, not at the end of the sequence, so if you are directly in front of the camera, it will focus on you and not the scene behind you. Another good use of the self-timer is for long exposures when the camera is on a tripod. This allows you to trigger the camera and remove your hand from touching the camera before the shutter goes off, helping to eliminate the possibility of camera shake.

The Digital Rebel does not come with a remote control—it is an optional accessory. A remote allows you to set the

camera off from within 16 feet away as long as communication between the remote control sensor (located on the hand-grip on the front of the camera) and the remote is uninhibited. When the shutter is triggered by remote, the camera fires about two seconds after you remotely release the shutter. This can be a good way of setting off the camera when using slow shutter speeds or in situations where you cannot be behind the camera. For both self-timer and remote use in bright light, be sure to cover the viewfinder so that your exposures won't be affected by extraneous light.

Manual Focus (MF)

There are times that you simply cannot use the autofocus. Maybe the camera is having trouble finding something to focus on. Perhaps AF focuses on the wrong place in the scene. Or it could be that you need a special focus setting for depth-of-field effects, or you are working up close where autofocusing can be tough. This is when you need manual focus. Manual focusing is pretty simple on Canon lenses—just slide the switch at the base of the lens from AF to MF and focus with the lens's focusing ring (the narrow ring at the front—not the base—of the lens) until the image looks sharp in the viewfinder. Be sure that the diopter is adjusted to your eye.

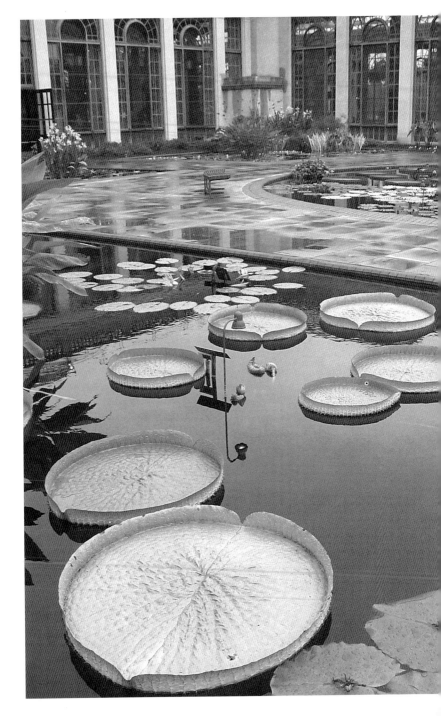

Composition

A Few Pointers

Good composition is good composition, whether you're using film or a digital camera. However, shooting with a digital camera can change the way you respond to composition, and will likely improve how your photographs look.

The key to a good composition is awareness of your subject and its surroundings. In addition, it concerns the way in which elements within the picture are arranged and related: subject, foreground, background, colors, shapes, textures, and so forth. Many guidelines have been established to help photographers better arrange these components. Regardless of the "rules," be sure to keep these tips in mind when striving for good composition:

- The subject of the photograph should be served by the composition. If the subject is obscured, the pictorial arrangements within the frame will be confusing or distracting.

- Be true to your own photographic style. Following arbitrary rules that work for someone else but not you is a sure way of being disappointed.

- The composition should be clear and understandable to most viewers.

- Compose the image to reflect your unique perception of the world.

The repetition of curved shapes works wonders in creating a sense of depth in this two-dimensional image of water lilies at Longwood Gardens. (©Jeff Wignall).

A good composition clearly serves your subject matter. This photo is composed to emphasize the relationship between woman and tortoise without any distracting intrusions.

There are three important choices that photographers must make. They are easy to remember but they do take some thought and effort to actually manifest in your composition. These choice are:

1. *What should I include?* Obviously, you must decide upon a subject to include in the photograph, but what else? How much of the subject? How much of the surroundings? Are there striking pictorial elements to include that will add drama and interest to the image? Why are you taking this photograph? The purpose of your photo strongly influences what needs to be included in it.

2. *What should I exclude?* What needs to be kept out of the photo? There is usually some distraction within the photographic field that will take away from the appeal of your photograph: telephone poles, feet, bright bits of color, unwanted people in the background, and so on. This can be a very important choice.

3. *How should I arrange the shot?* After you've decided on which elements to include, and excluded those unwanted distractions, you need to find a way to compose what's left in a pleasing arrangement that defines relationships among these picture elements. The relationships are always there; you just have to decide which parts of the relationships to emphasize, as well as where you want your main subject matter to appear in the frame.

The Rule of Thirds

There is one important guideline in photography, tried and true, that will help create pleasing and acceptable compositions. It is called the Rule of Thirds. Divide your picture area into thirds from top to bottom, then again from left to right. This arranges the photo into a grid of nine equal rectangles. The way to use this grid is to put important lines of the composition (such as a horizon or the edge of a building) on the horizontal or vertical grid lines. The subject is then placed at one of the four intersections of the grid lines. This situates the subject away from the center of the frame and generally creates an interesting composition. Be aware, however, that you can't force this picture scheme on every single scene you come across. The world doesn't always align itself to match the thirds of your viewfinder. Use the Rule of Thirds as a guide to practice photo composition, but don't let it limit you. Be creative with your picture taking!

Depth of Field

Depth of field is the distance in front of and behind a specific plane of focus that is acceptably sharp. Depending on what you want to do with a photograph, you can adjust this distance. Sometimes you want depth of field to be quite deep (perhaps with a landscape shot), while at other times a shallow depth of field will serve best (as in compositions where you want to sharpen a subject by setting it off against a soft background). Depth of field is affected by three things:

Shallow depth of field was employed in this photograph by selecting a wide aperture.

1. *Distance* to the subject (as you get closer, depth of field gets shallower)

2. *Focal length* (wide-angle lenses give more apparent depth of field than telephotos)

3. *F/stop* (smaller apertures – those with larger numbers such as f/11 or f/16 – give more depth of field than wide apertures like f/2.8).

With the Digital Rebel, you can check your depth of field by reviewing the shot on the LCD monitor. You can then magnify and scroll to different portions of the image, double-checking the sharpness to be sure important parts of the photo are in focus. If your depth of field does not include everything you wanted in the plane of focus, try adjusting your focus point placement or aperture settings. When shooting moving subjects, like at a soccer match, you can check depth of field details before the action occurs by tak-

ing a photo of a different subject about the same distance away as those subjects that you plan to photograph.

Composing Panoramics

Photographers have loved the sprawling panoramic image for a long time. Years ago, it was very popular for photographers to take multiple photos of a scene, one right after the other, then cut out and overlap the resulting prints for an interesting panoramic. If you wanted a seamless image, you had to be prepared to spend a lot of money on special panoramic cameras. Some 35mm-film cameras have a panoramic setting, but this actually just crops the center stripe of the slide or negative and doesn't use the full image.

With a digital camera, anyone can build a panoramic photo. First, attach your Digital Rebel to a tripod and take several overlapping photos to cover the wide scene. You can then put the photos together on your computer using automated panoramic software. Here are some guidelines to consider when trying your own panoramic photography:

- Be sure your scene works for a panoramic shot. Avoid a shot that has a lot of blank space on both sides of your subject. Look for something that has interesting picture elements throughout the panoramic image area.
- Moderate and telephoto focal lengths are easiest to work with. Wide-angle shots can be hard to stitch together.
- Use a tripod. It is possible to handhold a panoramic series, but they are harder to stitch together.
- Try using Manual exposure and uniform white balance with each shot so the photo series stays consistent in tone and color.
- Level your camera. A tool such as an inexpensive bubble level will make it easier to line up the images for the completed panoramic. (Some tripods have built-in levels.)
- Pick a starting point (it may help to choose something that stands out in the scene) and move methodically from left to right, or right to left if you prefer.

- Overlap each photo by 30-50 percent. Try several different sized overlaps to see what amount of overlap works best for you.
- Experiment with vertical panoramics as well as the obvious horizontal. Tall buildings and waterfalls can be very effectively shot this way.

Check Your Photos

Use the Digital Rebel's LCD monitor to study your composition. You can determine if you included enough of the subject or background, or whether you included too much. You can check to make sure that you have excluded distractions and any annoying intrusions into the photo. You can also examine how well the relationships between subject, background and foreground are working for your shot.

If your subject is still present, you can take another photo if you don't like any part of your picture. You can choose which photos to keep and which to erase. Digital photography encourages you to shoot more freely because you aren't wasting film and don't have to deal with multiple rolls. Since you can always clear extra memory by erasing photos, you can experiment with many different composition ideas. That's the best way to get better photos. Take a picture, then look at it, and see what needs to be corrected. Even if nothing needs correction, is it a photo you really like? Can you create an even better composition with the same subject?

With film, there is a tendency to play it safe and depend on conservative compositions. The safe photo might not be exciting, but at least you know it will provide an acceptable image of your subject. With the Digital Rebel you can exper-

Shooting multi-image panoramics gives a different perspective and scope to the spreading landscape.

iment with finding new ways of seeing your subject, new ways of communicating your unique vision through photography. There is no cost to this experimentation except time.

You can take as many variations of your subject as you want, and it is not an "either/or" decision. Go ahead and try all the compositions you can think of; take horizontal shots and vertical shots, move in close to the subject or stand far away, use your widest angle or longest telephoto, experiment with more and less depth of field. You will end up with a wide variety of shots that you can pick and choose from right away or later on. It's up to you! Plus, experimentation is truly a great learning tool that works at any level of experience – you can compare the variations and refine what works best for you.

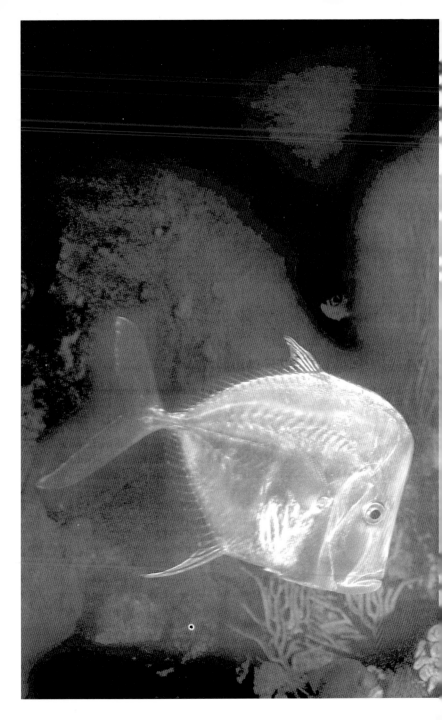

The Flash

Electronic flash is not just a supplement for insufficient lighting, it can also be a wonderful tool for creative photography. Flash is highly controllable, its color is precise, and the results are repeatable. However, the challenge is getting the right look and many photographers shy away from using flash because they aren't happy with the results. This is because on-camera flash can be harsh and unflattering and taking the flash off the camera used to be a complicated procedure with less than sure results. The Canon EOS Digital Rebel's sophisticated flash system eliminates many of these concerns and, of course, the LCD monitor gives instantaneous feedback. This alleviates the guesswork. With digital, you take a picture and you know immediately whether the flash exposure is right or not. You can then adjust the light level higher or lower, change the angle, soften the light, color it, and more. Just think of the possibilities:

- *Fill flash:* Fill in harsh shadows in all sorts of conditions and see exactly how well the fill is working. Often, you'll want to dial down an accessory flash to make its output more natural looking.

- *Off-camera flash:* Putting a flash on a dedicated flash cord will allow you to move the flash to positions away from the camera and still have it work automatically. Using the LCD monitor, you can see exactly what the effects are so you can move the flash up or down, left or right, for the best light and shadows on your subject.

Using the flash off camera with a dedicated cord will increase your options in using flash as a creative tool in photography.

143

Fill flash can enhance outdoor portraits.

- *Close-up flash:* This used to be a real problem except for those willing to spend some time experimenting. Now you can see exactly what the flash is doing to the subject (test on something nearby if you are after a moving subject like an insect). This works fantastically well with off-camera flash as you can "feather" the light (aim it so it doesn't hit the subject directly) to gain control over its strength and how it lights the area around the subject.

- *Multiple flash:* Modern flash systems have made exposure with multiple flash much better, plus many manufacturers have created cordless systems. However, since the flash units are not on continuously, they can be hard to place. Not anymore—with the Digital Rebel it is easy to set up the flash, then take a test shot. Does it look good, or not? Make changes if you need to. This is an extremely fast way of learning to use multiple flash.

- *Colored light:* Many flashes look better with a slight warming filter on them, but this is not what this tip is

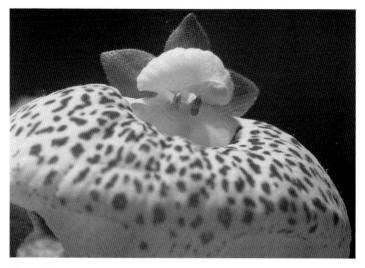

Using flash for close-up images lets you get maximum sharpness.

about. With multiple light sources, you can attach colored filters (also called gels) to the various flashes so that different colors light different parts of the photo (this can be a very trendy look).

- *Balancing mixed lighting:* Architectural and corporate photographers have long used added light to fill in dark areas of a scene so the scene looks less harsh. Now you can double-check the light balance on your subject using the LCD monitor. You can even be sure the added light is the right color by attaching filters to the flash to mimic or match lights (such as a green filter to match fluorescents).

Guide Numbers

When shopping for a flash unit, it is helpful to compare guide numbers. A guide number (GN) is a simple way to state the power of the flash unit. (It's computed as the product of aperture value and subject distance) and is usually

The Digital Rebel's built-in flash pops up higher above the lens than that of most other cameras.

included in the manufacturer's specifications for the unit. Since guide numbers are expressed in feet and/or meters, distance is part of the guide number formula. Guide numbers are usually based on ISO 100 film, but this can vary, so check the film speed reference when comparing guide numbers for different units. If the flash units you are comparing have zoom-head diffusers, make sure you compare the guide numbers for similar zoom-head settings.

The Built-in Flash

The Digital Rebel's on-camera flash opens to a higher position than those on many other cameras. This creates a larger distance between the flash and the lens axis, which reduces the red-eye effect, as well as the danger of light from the flash being blocked by lens hoods or long lenses. The built-in pop-up flash unit has a guide number of 39 feet (or 12 meters) with ISO 100. While not hugely powerful, it covers the picture angle of a 28mm lens. The recycle time is about two seconds. A flash pictogram e.g.: A flash pictogram ⚡ at the bottom left of the viewfinder display signifies when the flash is ready. With weak light, or backlight, the flash automatically pops up in the Full Auto Mode, as well as in the Close-Up, Portrait, and Night Portrait PIC modes. In Program AE, Shutter-priority, and Aperture-

priority modes, as well as Manual exposure mode, the flash unit must be activated manually by pushing the flash button located just to the left of the built-in flash. To turn the flash off, you must press the flash back down into the camera.

The range of the camera flash is only a few yards—sufficient for most snapshots of people. When using a higher ISO, you can usually light statues in churches and museums, or even sports action using the built-in flash. If it is too weak for certain subjects, use either a faster ISO or an EX flash unit.

Note: The built-in flash can't be used at the same time as accessory flash units.

Flash Synchronization

The Canon Digital Rebel is equipped with an electromagnetically timed, vertically traveling focal-plane shutter. One characteristic of focal-plane shutters is that at shutter speeds faster than the flash sync speed, the entire surface of the sensor will not be exposed at the same time. The shutter forms a slit, which exposes the sensor as it moves across it. If you use flash with a shutter speed that is higher than the flash sync speed, you only get only a partially exposed picture. However, at the flash sync speed or below, the whole sensor surface will be exposed. With the Digital Rebel the maximum flash sync speed is the 1/200 second. When the camera or the shoe-mounted system accessory flash is turned on, the camera sets the flash synchronization speed automatically.

Red-eye Reduction

Many photos of people or pets are ruined by red-eye. This unsightly effect occurs under low flash angles, when the retina of the eye reflects light directly back to the camera lens causing pupils to appear red in the photograph. The Digital Rebel is equipped with a red-eye reduction feature that decreases this effect. If you would like to turn red-eye

reduction on, just press MENU and select the Red-eye On option from the shooting menu ⬛ . The red-eye reduction lamp (located just above and to the left of the lens when looking at the front of the camera) will light up when you press the shutter button halfway, contracting the pupils and reducing the possibility of red-eye. (The flash emits a beam of light, or a preflash, for approximately 1.5 seconds. This is indicated by a moving bar in both the viewfinder and on the LCD panel.) Keep in mind that red-eye reduction is exactly that – it cannot guarantee that it will eliminate red-eye in your picture, but you can always retake the shot after reviewing it on the LCD monitor. Results will vary depending on the color of the subject's eyes (red-eye is more prevalent with blue eyes), the focal length of the lens in use, the distance to the subject, and the level of room lighting.

Here are some other ways to reduce red-eye:

• Ask the subject not to look directly at the lens

• Turn up the room lights, which will cause the iris in the eye to close down.

• Use shoe-mounted accessory units, which have a larger flash-to-lens axis angle. Red-eye is less prevalent with accessory rather than on-camera flash.

Flash Exposure (FE) Lock

The Digital Rebel does not have flash exposure compensation. However, it does have flash exposure (FE) lock capability. To use the FE lock, first make sure the flash is popped up (check in the viewfinder display to see that the flash icon ⚡ is illuminated). Now, focus on your subject by holding down the shutter button part way to lock autofocus (keep the shutter button halfway depressed for the next steps). Next, aim the center of the viewfinder at the important part of the subject and press the ✳ button (found at the top right of the back of the camera, just below the Mode Dial). The camera

will send out a pre-flash and calculate the flash exposure (the * icon will illuminate in the viewfinder). Now, reframe your composition and take the picture. This process makes flash exposure more accurate.

Using the same principle, you can make the flash weaker or stronger. Instead of pointing the viewfinder at the subject to set flash exposure, point it at something white or a subject closer to the camera. That will cause the flash to give less exposure. For more light, aim the camera at something black or far away. With a little experimenting, and reviewing the LCD monitor, you can very quickly establish appropriate flash control for particular situations.

For the most control over the flash, use the camera's manual settings. Set an exposure that is correct overall for the scene then pop the flash up. (Flash exposure will still be E-TTL automatic.) The shutter speed (as long as it is 1/200 second or slower) controls the overall light from the scene (and the total exposure). The f/stop controls the exposure of the flash. So to a degree, you can make the overall scene lighter or darker by changing shutter speed, with no direct effect on the flash exposure.

Flash in the Basic Zone (Full Auto & PIC Modes)

In the Full Auto Mode and the PIC program modes either the built-in camera flash or a shoe-mounted system accessory flash unit will essentially do all the thinking. With insufficient lighting or backlighting, the built-in flash automatically pops up in Full Auto, Close-Up, Portrait, and Night Portrait modes. Hot shoe accessory flash units can be used in the Landscape and Sport modes. Red-eye reduction can be activated at any time. Full Auto Mode is highly recommended for beginners or when using a point-and-shoot style of photography. In this mode, the photographer can take advantage of fully automatic flash and exposure control in order to concentrate attention on the subject.

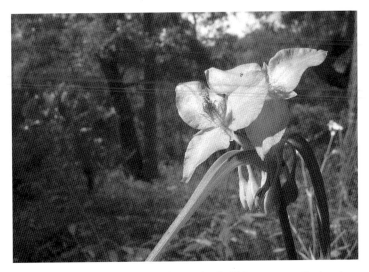

Press the flash button to activate the built-in camera flash when shooting in the Creative Zone modes.

Flash in the Creative Zone

In Program mode (P), flash photography is suitable for all types of photos where supplementary light is needed. The built-in camera flash must be activated by pressing the flash button, or you can attach an EX Speedlite accessory flash unit and simply switch it to the ON position. That is all you have to do, the rest is done automatically by the camera's computer. Even so, you should pay attention to the flash symbol ⚡ in the viewfinder to be sure that the flash is charged when you are ready to take your picture. Speedlite EX flash units should be switched to E-TTL and the ready light should be on, indicating that the flash is ready to fire.

The Digital Rebel sets the flash synchronization shutter speed of 1/200 second automatically in P mode and also selects the correct aperture. When the flash is turned on, any program shift that has been set will be canceled. Flash Exposure (FE) Lock can be used with EX flash units as well as with the built-in flash. For high-speed sync up to 1/2000 second, use EX flash units or the Macro Lights MT-14EX and MT-24EX.

Shutter-priority mode (Tv) is a good choice in situations where you want to control the shutter speed for flash photographs. Since a change of shutter speed in Program mode is canceled when the flash is turned on, you can't take flash photographs using program shift. In Tv mode, you can use either the camera flash or an accessory flash. You can set the shutter speed before or after the built-in flash is activated, or a dedicated accessory flash is turned on. All shutter speeds between 1/200 second and 30 seconds will synchronize with the flash. If a shutter speed faster than 1/200 second is set, the camera automatically sets itself back to 1/200 second when the flash is ready to fire.

High-speed synchronization can be used with all EX-series flash units. This function must be activated on the flash unit itself and is indicated by an H symbol both on the LCD panel and in the viewfinder. In this function any shutter speed between 1/125 and 1/2000 second can be used. The aperture is set automatically as a function of the selected shutter speed and the ambient light. If the smallest or largest aperture flashes (on the LCD panel or in the viewfinder display), you should select another shutter speed to prevent incorrect exposures. FE Lock can also be used with all EX flash units.

With E-TTL Flash in Tv mode, synchronization with longer shutter speeds is a creative choice that allows you to control ambient-light background exposure. A portrait of a person at dawn in front of a lit city window attempted with a conventional TTL flash would illuminate the person correctly but

would cause the background to go black. However, using Shutter-priority, you can control the exposure of the background. To refine the accuracy, you could take a separate meter reading of the ambient light and set the shutter speed accordingly. (A tripod is recommended to prevent camera shake with long exposures)

Aperture-priority mode (Av) allows you to control depth of field in the composition. By selecting the aperture, you are also able to influence the range of the flash. These techniques work with both the built-in on-camera flash and accessory hot-shoe flashes. The aperture can be selected with the Main Dial. Then the camera calculates the lighting conditions and sets the correct flash synchronization speed automatically. When using Av mode with an EX-series flash unit, high-speed synchronization is activated automatically in very bright light.

Manual camera exposure mode (M) can be used with both the convenience of the built-in camera flash or the accuracy of E-TTL EX-series accessory flash units. This mode gives you the most choices in modifying exposure. The photographer who prefers to adjust everything manually can determine the relationship of ambient light and electronic flash by setting both the aperture and shutter speed. Any aperture on the lens and all shutter speeds between 1/200 second and 30 seconds can be used. If a shutter speed above the normal flash sync speed is set, the Digital Rebel switches automatically to 1/200 second.

M mode also offers a number of creative possibilities for using flash in connection with long shutter speeds. You could use zooming effects with smeared background and a sharply rendered main subject, or take photographs of objects in motion with a sharp "flash core" and indistinct outlines.

Canon Speedlite EX Flash Units

Canon offers a range of accessory flash units (called Speedlites) in the EOS system. These are highly portable and can mount on the camera's hot shoe or be used off camera with a dedicated cord. The Digital Rebel is compatible with a series of units known as EX Speedlites. The Speedlite units won't replace studio strobes, but they are remarkably versatile. The EX-series flashes range in power from the Speedlite 550EX with a maximum GN of 180 (in feet at ISO 100) to the small and compact Speedlite 220EX with a GN of 72 (in feet at ISO 100).

Speedlite EX-series flash units offer a wide range of features to expand your creativity. These are designed to work with the camera's microprocessor. Together they offer the advantage of E-TTL exposure control, which extends the abilities of the Digital Rebel considerably. (Remember to use the guide number—GN, see page 145—to compare and contrast flashes when you're looking to make a purchase)!

I also strongly recommend getting Canon's Off-Camera Cord 2, an extension cord for your flash. With this cord, the flash can be moved away from the camera for more interesting light and shadow. You can aim light from the side or top of a close-up subject for variations in contrast and color. If you find that you get an overexposed subject, rather than dialing down the flash (which can be done on certain flash units), just aim the flash a little away from the subject so it doesn't get hit so directly by the light. That is often a quick fix for overexposure of close-ups.

The Speedlite 550EX is the top-of-the-line model, offering a greater range and more features than the other EX models. It provides very-high performance with a GN of 182 feet (55 meters) when the zoom head is positioned at 105mm and ISO 100. The guide number decreases as the angular coverage increases for wider angle lenses, but is still quite high with a GN of 139 feet (42 meters) at 50mm, or GN 99 feet, (30 meters) at 28mm. The tilt/swivel zoom head on the

550EX covers focal lengths from 24mm to 105mm. The zoom positions (which correspond to the focal lengths 24, 28, 35, 50, 70, 80 and 105mm) can be set manually or automatically. (The flash reflector zooms with the lens). With the built-in retractable diffuser in place, the flash coverage is wide enough for a 17mm lens.

The large, illuminated LCD panel on the 550EX provides clear information on all settings: flash function, reflector position, working aperture, and flash range in feet or meters. When you press the depth-of-field preview button (just below the lens release button on the Digital Rebel), a one-second burst of light is emitted, so you can judge the effect of the flash. The 550EX also has six custom settings which can be user defined.

The Canon Speedlite 420EX is less complicated, more compact, and less expensive than the top model. The Canon Speedlite 420EX offers E-TTL flash control, wireless E-TTL operation, and high-speed synchronization. The 420EX flash unit provides high performance with a GN of 138 feet (42 meters) at ISO 100 with the zoom reflector set for 105mm (somewhat weaker than the 550EX, but still quite powerful). The tilt/swivel zoom reflector covers focal lengths from 24 to 105mm. The zoom head operates automatically for focal lengths of 24, 28, 35, 50, 70 and 105mm. The setting for wireless E-TTL is made on the flash foot. When using multiple flashes, the 420EX can be used as a slave unit, but not as a master flash.

Other Speedlite EX flash units include the Speedlite 220EX and 380EX. The 220EX is an economy alternative EX-series flash. The Speedlite 380EX is a discontinued model, but is still a good choice if you can find one on the used market. Both of these models offer E-TTL flash and high-speed sync but do not offer wireless TTL flash or exposure bracketing. In addition, there are two specialized flash units for close-up photography that work well with the Digital Rebel: the Macro Twin Lite MT-24EX and the Macro Ring Lite MR-14EX. They provide direct light on the subject.

Note: The power pack of both of these specialized flash units fits into the flash shoe of the camera. In addition, both macro flash units offer the same technical features as the 550EX, including E-TTL operation, wireless E-TTL flash, and high-speed synchronization among others. The MT-24EX models can also be used for wireless E-TTL flash.

The Macro Twin Lite MT-24EX uses two small flashes affixed to a ring that attaches to the lens. These can be adjusted to different positions to alter the light and can be used at different strengths so one can be used as a main light and the other as a fill light. If both flash tubes are switched on, they produce an ISO 100 GN of 72 feet (22 meters), and when used individually the guide number is 36/11. It does an exceptional job with directional lighting in macro shooting.

The Macro Ring Lite MR-14EX has an ISO 100 GN of 46 feet (14 meters) and both flash tubes can be independently adjusted in 13 steps from 1:8 to 8:1. It is a flash that encircles the lens and provides illumination on axis with it. This results in nearly shadowless photos (the shadow falls behind the subject compared to the lens position, though there will be shadow effects along curved edges) and is often used by photographers who want to show all the fine detail and color in a subject. It cannot be used for varied light and shadow effects. This flash is commonly used in medical and dental photography so that important details are not obscured by shadows.

Using Accessory Speedlites

The Digital Rebel will operate in E-TTL with EX Speedlite accessory flash units. E-TTL (Evaluative-Through-The-Lens) flash metering achieves a balance between flash and day-light, because both electronic flash and ambient light are factored into the exposure. Flash photography becomes as simple as photographing with daylight. The camera analyzes the shot and, using its thirty-five-zone evaluative metering, measures the light to produce a balanced exposure. This

Only the EX-series flash units are fully TTL functional with the Digital Rebel. However, the powerful Canon Speedlite 550EX is compatible with all Canon EOS cameras.

works particularly well with the Canon Speedlite 420EX and with the top-of-the-line 550EX. (E-TTL flash control will function with any EX-series flash unit.)

When the Digital Rebel is used with older system flash units (such as the EZ series), the flash unit must be set to manual and TTL will not function. For this reason, Canon EX Speedlite system flash units are recommended primarily for use with the camera.

Bounce Flash

Direct flash can often be harsh and unflattering, causing heavy shadows behind the subject or underneath features such as eyebrows and bangs. Bouncing the flash softens the light and creates a more natural-looking light effect.

Several Canon Speedlite EX accessory flash units feature heads that are designed to tilt so that the shoe-mounted flash is not aimed directly at the subject. You can point the flash toward the ceiling or a wall to produce soft, even lighting. However, the ceiling and walls must be white or neutral gray, or they may cause an undesirable color cast in the finished photo.

Wireless E-TTL Flash

With the wireless E-TTL feature you can use up to three groups of Speedlite 550EXs or 420EXs for more natural lighting or emphasis (the number of flash groups is limited to three, not the number of actual flash units). A switch on the back of the foot of the 550EX allows you to select whether the flash will be used as a master or a slave flash in the set up. The 420EX can only be used as a slave unit. Other wireless flash options include the Speedlite infrared transmitter (ST-E2), or the Macro Twin Lite MT-24EX.

To operate wireless TTL, a Speedlite 550EX is mounted in the flash shoe on the camera and functions as the master unit, while the slave units are set up in the surrounding area. The light ratio of slave units can be varied manually or automatically. With E-TTL (wireless) control several different Speedlite 420EXs and 550EXs can be controlled at once, even when utilizing high-speed sync.

Lenses & Accessories

The Digital Rebel belongs to an extensive family of Canon EOS compatible equipment, including lenses, flashes, and other accessories. With this wide range of available options, you could expand the capabilities of your camera quite easily should you want to. Canon has long had an excellent reputation for its lenses, and several other non-OEM manufacturers offer quality Canon compatible lenses as well.

The Digital Rebel can use over 50 Canon EF lenses, ranging from wide-angle to tele-zoom, as well as very wide to extreme telephoto single-focal-length lenses. Keep in mind that both the widest angle and the farthest zoom are multiplied by the Digital Rebel's 1.6x magnification factor. The EF 14mm f/2.8L lens, for example, is a super-wide lens with a 35mm camera, but offers the 35mm-format equivalent of a 22mm wide angle when attached to the Digital Rebel—wide, but not super-wide. On the other hand, put a 400mm lens on the camera and you get the equivalent of a 640mm telephoto zoom—a big boost with no change in aperture (be sure to use a tripod for these focal lengths)!

Choosing Lenses

Think hard about your specific photographic needs before spending money on lenses, and then choose ones that meet those needs. This seems obvious, but many enthusiasts will buy a lens based on what they see a professional using, or what their friends have. The focal length and design of a lens will have a huge affect on how you photograph. The right lens will make photography a joy; the wrong one will make you leave the camera at home.

A telephoto zoom lens is one of the best investments you can make to add versatility to your Digital Rebel system. The short end of a telephoto zoom's range is ideal for portraits and the longer end is great for sports and nature photography.

One approach for choosing a lens is to determine if you are frustrated with your current lenses. Do you constantly want to see more of the scene than the lens will allow? Then consider a wider-angle lens. Or maybe the subject is too small in your photos. Then look into acquiring a zoom or telephoto lens.

Certain subjects lend themselves to specific focal lengths. Wildlife and sports action are best photographed using focal lengths of 300mm or more, although nearby action can be managed with 200mm. Portraits look great when shot with focal lengths between 80-100mm. Interiors often demand wide-angle lenses such as 20 or 24mm. Many people also like wide-angles for landscapes, but telephotos can come in handy for distant scenes. Close-ups can be shot with nearly any focal length, though skittish subjects such as butterflies might need a longer lens. The focal lengths described above are traditional 35mm equivalents, because most people who know photography are familiar with these measurements. However, as mentioned previously, on digital cameras the standard 35mm focal lengths do not act the way they did with film. That is because most digital sensors are much smaller than film, so they crop the area seen by the lens, essentially creating a different format.

Effectively, this magnifies the subject within the image area of the Digital Rebel and results in the lens acting as if it has been multiplied by a factor of 1.6 compared to 35mm film cameras. So, a 28mm lens on the Digital Rebel would act more like the way a 45mm lens would perform for a 35mm-film camera.

Note: This is exactly the same thing that happens when one focal length is used with different sized film formats. For example, a 50mm lens is considered a mid-range focal length for 35mm, but it would be a wide-angle for medium format cameras.

This is great news for the photographer who needs long focal lengths for wildlife or sports. A standard 300mm lens for 35mm film now acts like a 480mm lens on the Digital

The Digital Rebel's 1.6x magnification factor allows you to zoom in even closer on distant subjects than you would be able to using the same lens on a 35mm SLR.

Rebel. But it is tough news for people who need wide-angles, since the width of what the digital camera sees is significantly cropped in comparison to what a 35mm camera would see using the same lens. You will need lenses with much shorter focal lengths to see the same amount of wide-angle you may have been used to with film. (A number of manufacturers have made lenses specifically for digital SLRs. These lenses are smaller in size and have been catered mostly for the wider focal lengths in order to compensate for the loss of wide-angle when shooting with digital.)

Zoom vs. Single-focal-length Lenses

When zoom lenses first came on the market, they were not even close to a single-focal-length lens in sharpness, color rendition, or contrast. Today, you can get superb image quality from either type. There are some important differences, though. The biggest is maximum f/stop.

Zoom lenses are rarely as fast (e.g. rarely have as big a maximum aperture) as single-focal-length lenses. A 28-200mm zoom, for example, might have a maximum aperture at 200mm of f/5.6, yet a single-focal-length lens might be f/4 or even f/2.8. When zoom lenses come close to a single-focal-length lens in f/stops, they are usually considerably bigger and more expensive than the single-focal-length lens. Of course, they also offer a whole range of focal lengths, which a single-focal-length lens cannot do. There is no question that zoom lenses are versatile.

Canon Brand Lenses

Canon brand lenses include some unique technologies. Canon pioneered the use of tiny autofocus motors in its lenses. In order to focus quickly, the focusing elements within the lens need to move with quick precision. Canon developed the lens-based ultrasonic motor for this purpose. This technology makes the lens motor spin with ultrasonic oscillation energy instead of the traditional drive-train system (which tends to be noisy). This allows lenses to autofocus nearly instantly and with no noise (plus it uses less battery power). Canon lenses with this motor are labeled USM (lower-priced Canon lenses have small motors in the lenses, too, but these don't use USM technology and can be slower and noisier).

Canon was also was a pioneer in the use of image-stabilizing technologies. IS (Image Stabilizer) lenses use very sophisticated motors and sensors to adapt to slight movement during exposure. It's pretty amazing—the lens actually has vibration-detecting gyro stabilizers that move a special image-stabilizing lens group in response to movement of the lens. This dampens movement that occurs from handholding a camera and allows much slower shutter speeds to be used. IS also allows big telephoto lenses (such as the EF 500mm IS lens) to be used on much lighter weight tripods.

The technology is part of many zoom lenses, and does a great job overall. However, IS lenses in the mid-focal length

ranges tend to be slower zooms compared to single-focal-length lenses. For example, compare the EF 28-135mm f/3.5-5.6 IS lens to the EF 85mm f/1.8. The former has a great zoom range, but allows in less light at max aperture. At 85mm (a good focal length for people), the EF 28-135mm is an f/4 lens, over two stops slower than the f/1.8 single-focal-length lens when both are shot "wide-open" (typical of low light situations). While you could make up that two stops in "handholdability" due to the IS technology, that also means you must use two full shutter speeds slower which can be a real problem in stopping subject movement.

Canon's L-series lenses use special optical technologies for extremely high lens correction. These include low-dispersion glass, fluorite elements, and aspherical designs. UD (ultra-low dispersion) glass is used in L-series telephoto lenses to minimize chromatic aberration, a common problem for telephoto lens designers. Chromatic aberration occurs when the lens can't focus all colors equally at the same point on the sensor (as well as on the film in a traditional camera). This results in less sharpness and a lot less contrast. Low-dispersion glass focuses colors more equally for sharper, crisper images.

Fluorite elements are even more effective (though more expensive) and have the corrective power of two UD lens elements. Aspherical designs are used with wide-angle and mid-focal length lenses to correct the challenges of spherical aberration in such focal lengths. Spherical aberration is a problem caused by lens elements with extreme curvature (usually found in wide-angle and wide-angle zoom lenses). Glass tends to focus light differently through different parts of such a lens, causing a slight, overall softening of the image even though the lens is focused sharply. Aspherical lenses use a special design that compensates for this optical defect.

Since the Digital Rebel does not use the entire area covered by a lens designed for 35mm SLRs, Canon has designed some compact lenses that only cover the smaller

The Canon EF-S 18-55mm lens, which Canon designed for use with the Digital Rebel, covers a range that is equivalent to a 28-90mm zoom lens on a 35mm SLR camera.

digital format, like the EF-S 18-55mm f/3.5-5.6 lens, for example. This particular lens cannot be used on other Canon digital cameras because it has a shorter back focus than regular EF lenses (meaning it sits back farther in the camera body). It is a very compact, lightweight lens with a 35mm equivalent focal length of approximately 28-90mm that works quite well with the Digital Rebel. It includes an aspherical lens element for increased sharpness and can focus to just under a foot without any additional accessories.

Independent lens manufacturers also make some excellent lenses that fit the Digital Rebel. I've seen quite a range in capabilities with these lenses. Some include low-dispersion glass and are stunningly sharp. Others may not match the best Canon lenses, but offer features (such as focal length range) that make them well worth considering. To a degree, you do get what you pay for. A low-priced Canon lens compared to a low-priced independent lens probably won't be

much different. On the other hand, the high level of engineering and construction found on a Canon L-series lens can be difficult to match.

Canon also makes some specialized lenses. Macro lenses are single-focal-length lenses optimized for high sharpness throughout their focus range, from very close 1:2 magnification to infinity. These lenses range from 50mm to 180mm. Tilt-shift lenses are unique lenses that shift up and down or tilt toward or away from the subject. They mimic the controls of a view camera. Shift lets the photographer keep the back of the camera parallel to the scene and move the lens to get a tall subject into the composition—this keeps vertical lines vertical and is extremely valuable for architectural photographers. Tilt changes the plane of focus so that sharpness can be changed without changing the f/stop. Focus can be extended from near to far by tilting the lens toward the subject, or sharpness can be limited by tilting the lens away from the subject (which has lately been a trendy advertising photography technique).

Close-Up Lenses & Accessories

Close-up photography is a striking and unique way to capture a scene. Percentage-wise, most of the photographs we see on a day-to-day basis are not close-ups, making those that do make their way to our eyes all the more outstanding. Quality close-ups can be easy and fun to shoot. The following are four of the most common close-up options:

1. *Close-focusing zoom lenses with a macro or close-focus feature:* Most zoom lenses allow you to focus up-close without accessories, although focal-length choices may become limited when using the close-focus feature. These lenses are an easy and effective way to start shooting close-ups. Keep in mind, however, that even though these may say they have a macro setting, it is really just a close-focus setting and not a true macro as described below in option four.

Close-up filters are relatively inexpensive. They thread on the front of a lens and supply instant close-focus ability with no loss of light.

2. *Close-up accessory lenses:* You can buy lenses that screw onto the front of your lens to allow it to focus even closer. The advantage is that you now have the whole range of zoom focal lengths available and there are no exposure corrections. Close-up filters can do this, but the image quality is not great. More expensive achromatic accessory lenses (highly-corrected, multi-element lenses) do a superb job with close-up work, but their quality is limited by the original lens.

3. *Extension tubes:* Extension tubes fit in between the lens and the camera body of an SLR. This allows the lens to focus much closer than it could normally. Extension tubes are designed to work with all lenses for your camera (although older extension tubes won't always match some of the new lenses made specifically for digital cameras). Be aware that extension tubes do cause a light loss.

At close-focusing distance and high magnification, not only is the subject magnified, but so is camera movement. Thus, for best results always use a good tripod for shots such as this.

4. *Macro lenses:* Some new photographers don't know about the options above and think the only way to shoot close-ups is with a macro lens. Though relatively expensive, macro lenses are designed for superb sharpness at all distances and will focus from mere inches to infinity. In addition, they are typically very sharp at all f/stops.

Sharpness is a big issue with close-ups, and this is not simply a matter of buying a well-designed macro lens. The other close-up options can also give superbly sharp images. Sharpness problems usually result from three factors: limited depth of field, incorrect focus placement, and camera movement.

The closer you get to a subject, the shallower depth of field becomes. You can stop your lens down as far as it will go for more depth of field, or use a lens with a wider angle, but depth of field will still be limited. Because of this, it is critical to be sure focus is placed correctly on the subject. If the back

167

Switch to manual focus for greatest control of sharpness in the final photograph.

of an insect is sharp but its eyes aren't, the photo will appear to have a focus problem. At these close distances, every detail counts. If only half of the flower petals are in focus, the over-all photo will not look sharp. Autofocus up close can be a real problem with critical focus placement because the camera will often focus on the wrong part of the photo.

Of course, you can review your photo on the LCD monitor to be sure the focus is correct before leaving your subject. You can also try manual focus: focus the lens at a reasonable distance, then move the camera toward and away from the subject as you watch it go in and out of focus. This can really help, but still, you may find that taking multiple photos is the best way to guarantee proper focus at these close distances. Luckily, the Digital Rebel makes it easy to take lots of photos and double-check your work.

When you are employing close focus in your picture, even slight movement can shift the camera dramatically in

relationship to the subject. The way to help correct this is to use a high shutter speed or put the camera on a tripod. Two advantages to using a digital camera during close-up work are the ability to check the image to see if you are having camera movement problems, as well as the ability to change ISO settings from picture to picture to enable a faster shutter speed if you deem it necessary.

The best looking close-up images will often be ones that allow the subject to contrast with its background, making it stand out and adding some drama to the photo. There are three important contrast options to keep in mind. They apply to any photograph where you want your subject to stand out, but they can be easily applied to close-up subjects where a slight movement of the camera can totally change the background.

1. *Tonal or brightness contrasts:* Look for a background that is darker or lighter than your close-up subject. This may mean a small adjustment in camera position. Backlight is excellent for this since it offers bright edges on your subject with lots of dark shadows behind it.

2. *Color contrasts:* Color contrast is a great way of making your subject stand out from the background. Flowers are popular close-up subjects and, with their bright colors, they are perfect candidates for this type of contrast. Just look for a background that is either a completely different color (such as green grass behind red flowers) or a different saturation of color (such as a bright green bug against dark green grass).

3. *Sharpness contrast:* One of the best close-up techniques is to work with the inherent limit in depth of field and deliberately set a sharp subject against an out-of-focus background or foreground. Look at the distance between your subject and its surroundings. How close are other objects to your subject? Move to a different angle so that distractions are not conflicting with the edges of your subject. Try different f/stops to change the look of an out-of-focus background or foreground.

Note the deep contrast between the darkened sky and the clouds in this photo taken with a circular polarizer.

Filters

Many people these days assume that filters aren't needed for digital photography because adjustments for color and light can be made in the computer. By no means are filters obsolete! They actually save a substantial amount of work in the digital darkroom by allowing you to capture the desired color and tonalities for your image right from the start. Even if you can do certain things in the computer, why take the time if you can do it more efficiently while shooting?

Of course, the LCD monitor comes in handy once again. By using it, the Digital Rebel can assist you in getting the best from your filters. If you aren't sure how a filter works, you can simply try it and see the results immediately on the monitor. You don't have to worry whether or not your picture won't turn out. Just take the shot, review it, and make adjustments to the exposure or white balance to help the filter do its job. If a picture doesn't come out the way you would like, you can discard and retake it right away.

Attaching filters to the camera depends entirely on your lenses. Usually, a properly sized filter can either be screwed directly onto a lens or fit into a holder that screws onto the front of the lens. There are adapters to make a given size filter fit several lenses, but the filter must cover the lens from edge to edge or it will cause dark corners in the photo (vignetting). A photographer may even hold a filter over the lens with his or her hand.

There are a number of different types of filters. Start with the polarizer. This important outdoor filter should be in every camera bag. Its effects cannot be exactly duplicated with software because it actually affects the way light is perceived by the sensor.

This filter darkens skies at 90° to the sun (this is a variable effect), reduces glare (which will often make colors look better), removes reflections, and increases saturation. While you can darken skies in the computer, the polarizer reduces the amount of work you have to perform in the digital darkroom. This filter will rotate in its mount, and as it rotates, the strength of the effect changes. While linear polarizers often have the strongest effect, they can cause problems with exposure, and often prevent the camera from autofocusing. Consequently, you are safer using a circular polarizer with the Digital Rebel.

Most pros consider a graduated neutral density filter an essential tool. This filter is half clear and half dark (gray). It is used to reduce bright areas (such as sky) in tone, while not affecting darker areas (such as the ground). The computer can mimic its effects, but you may not be able to recreate the scene you wanted. A digital camera's sensor can only respond to a certain range of brightness at any given exposure, and if a part of the scene is too bright compared to the overall exposure, detail will be washed out and no amount of work in the computer will bring it back.

A neutral density gray filter can also be a helpful accessory. This simply reduces the light coming through the lens.

These filters come in different strengths, each reducing different quantities of light. They give additional exposure options under bright conditions, such as a beach or snow (where a filter with a strength of 4x is often appropriate). If you like the effects when slow shutter speeds are used with moving subjects, a strong neutral density filter (such as 8x) usually works well. Of course, the great advantage of the digital camera, again, is that you can see the effects of slow shutter speeds immediately on the LCD monitor so you can modify your exposure for the best possible effect.

Many amateur photographers buy haze/skylight filters, yet pros rarely use them. The idea behind them is to give protection to the front of the lens, but they do very little visually. Still, they can be useful when photographing under such conditions as strong wind, rain, blowing sand, or going through brush.

If you do use a filter for lens protection, a high quality filter is best. A cheap filter can degrade the image quality of the lens. Remember that the manufacturer made the lens/sensor combination with very strict tolerances. A protective filter needs to be literally invisible, and only high-quality filters can guarantee that. (UV filters are often used as lens protection filters.)

Tripods & Camera Support

If you want to get the most from your digital camera, you need to be aware that camera movement can affect sharpness and tonal brilliance in an image. Even slight camera movement during the exposure can cause the loss of fine details and the blurring of highlights. These effects are especially glaring when you compare an affected image to a photo that has no motion problems. In addition, affected images will not enlarge well.

You must minimize camera movement in order to maximize the capabilities of your lens and sensor. A steady hold on the camera is a start, along with squeezing the shutter

button rather than "punching" it. Fast shutter speeds, as well as using flash, also help to ensure sharp photos, although you can get away with slower shutter speeds when using wider-angle lenses. However, when shutter speeds go down, it is advisable to use to some sort of camera-stabilizing device. Tripods are the best known aid, but beanbags, monopods, mini-tripods, shoulder stocks, clamps, and more all help. Many photographers carry a small beanbag or a clamp pod with their camera equipment for those situations where the camera needs support but a tripod isn't available.

Check your local camera store for the variety of equipment available. A good tripod is an excellent investment. A cheap tripod can actually be wobbly and cause more problems than it solves. When buying a tripod, extend it all the way to see how easy it is to open, then lean on it to see how stiff it is. Both aluminum and carbon-fiber tripods offer great rigidity. Carbon-fiber is much lighter, but also more expensive.

The tripod head is a very important part of the tripod and may be sold separately. There are two basic types for still photography: the ball head and the pan-and-tilt head. Both designs are capable of solid support. The biggest difference between them is how you loosen the controls and adjust the camera. Try both and see which seems to work better for you. Be sure to do this with a camera on the tripod because that added weight changes how the head works.

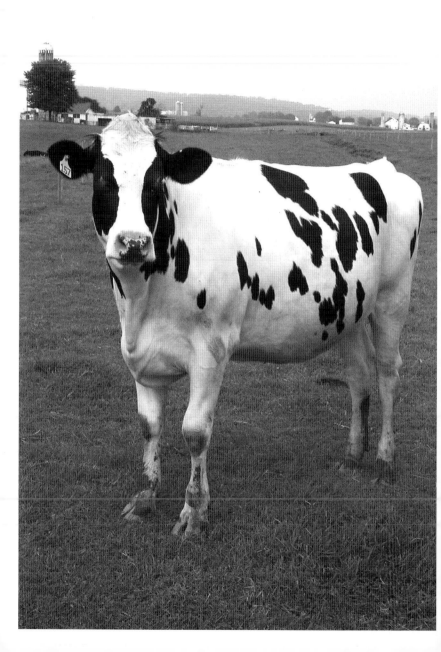

Playback Options

The LCD monitor is one of the best parts of shooting digital. It gives you immediate access to your images without any waste, making it better than a Polaroid print! The Digital Rebel actually has two LCD (liquid crystal display) areas – the LCD monitor and the LCD panel. The LCD panel is the elongated black and gray display that shows camera information such as exposure and white balance settings. You can

locate it just above the more squarely shaped LCD monitor on the back of the camera. The LCD panel is an important area to be aware of during picture taking because it lets you know what the camera is doing.

One of the best advantages of shooting with the Digital Rebel is the knowledge that you captured the perfect cow shot while you are still down on the farm. (©Jeff Wignall).

The Digital Rebel's instant review function allows you to see your picture immediately. However, it does use batteries faster than other options.

The Digital Rebel's 1.8-inch color LCD monitor is much brighter than the monitors of just a couple years ago, but it still takes a little practice to see it in bright light. You can adjust its brightness in the playback menu ▶ , but the easiest thing to do is to shade the monitor in bright light – use your hand, a hat or your body to block the sun.

When photographers who have worked with a point-and-shoot digital camera first use a digital SLR, they often notice that the LCD monitor cannot be turned on while shooting. Digital point-and-shoot cameras have so-called "live" LCD monitors but, like other digital SLRs, the Digital Rebel uses a mirror inside the camera to direct the image from the lens to the viewfinder. During exposure, the mirror flips up to allow the image to strike the sensor for the photograph. To gain a live LCD monitor, a camera must be able to use the sensor to see what is coming from the lens at all times, which is impossible with an SLR.

The Digital Rebel's LCD monitor is used, therefore, strictly for review and editing of images after they have been taken or, as Canon calls it, for playback. You have a number of important options as to how to best use the playback functions.

Note: Any camera buttons with blue-colored labels or icons refer to playback functions.

First, there is the instant review function. This results in the photo being displayed on the LCD monitor moments after the photo was taken. Most photographers like this as it gives a confirmation of the shot. Pressing the shutter button halfway will turn the LCD monitor back off. You may not want to use this feature if you need to get maximum time usage from your battery more quickly. Using the LCD monitor will drain the battery. Plus, there may be certain situations where the LCD monitor is distracting, such as in a dark room.

Image Review

Among other options, the playback menu allows you to determine how your image will be displayed after shooting.

There are two settings for image review, both accessible in the playback menu ▶ . You need to decide whether or not you want the image review function on, as well as whether you want picture info displayed with the image review. (Most photographers tend to leave image review on.) The playback menu allows you to decide how long the image review will be displayed on the LCD monitor. You can choose two, four, or eight seconds, and there is a fourth

option called "Hold." For each of the timed settings, the camera puts the image up on the LCD monitor for the selected time, or until you press the shutter button. In the Hold setting, the picture will stay on the LCD monitor indefinitely until you press the shutter button or the camera powers down for power conservation. I find that a two-second image review is too short, and four seconds only a little better. Hold is fine, except that it is easy to leave the image on the LCD monitor for longer than you intended (which will affect battery life), so I prefer eight seconds. The image is on long enough to examine, yet you can make it disappear by pressing the shutter button lightly at any time.

There is a little trick to force the camera to hold the image: press the erase button 🗑 located on the bottom left of the camera back, to the left of the LCD monitor. The other functions of the erase button will be discussed a little later, but for the purposes of a quick hold, you need only press it. Two choices will appear on the screen on top of the image, Cancel or OK, and Cancel is the auto-selected choice. As long as you don't press any buttons at this time, the image stays on screen. You can delete it if you want by moving the selection to OK (using the cross keys ✛) but, if you like the photo, either lightly press the shutter button or push the ⓢᴇᴛ button and the image will disappear from the screen (not from the memory card).

If you decide that you do want to keep the image review function on, you may want to select the Review On (Info) option. This option allows you to see other details about the picture along with the image itself. Directly to the right of the image is the histogram, and below that is the other shooting information. You can also access this data using the INFO. button if you prefer not to have this detailed information displayed with every image review.

The image review function only works with the last photo you shot, and you can use both the erase 🗑 and INFO. buttons with it. If you press the playback button ▶ (just above the erase button on the bottom left of the cam-

era back), the camera will display any images that have been recorded to the memory card. It first displays the last photo that you took. Then, you can move forward or backward among your images in two ways: either by pressing the right or left directional cross keys ✧ , or by rotating the Main Dial on the top of the camera (just behind the shutter button).

Rotating an Image

For easy viewing of photos shot with the camera in a vertical position, you have a couple of choices. One thing you can do is select Auto rotate from setup menu one ⚏⚏ . When this function is turned on, the camera will automatically rotate verticals so that they display up-and-down during playback. This feature comes in handy when looking at a lot of photos or preparing images for the camera's Auto Play function. However, in order to fit the vertical photo into the horizontal monitor, the camera will reduce the size of the image on screen (the image data and resolution remain unaffected). This can make it hard to evaluate the shot without a lot of magnifying. If you do not select Auto rotate, a tiny vertical image will still appear beside the full-size horizontal on the LCD monitor. You can also choose to rotate images in the playback menu ▶ . Select the Rotate option by scrolling down to it and pressing (SET) . Then, you can scroll through your images using the left and right-hand directional cross keys. Press (SET) again when the image you wish to rotate appears on the LCD monitor. Each time you press (SET) , the image will rotate clockwise. When the image is rotated as you would like it, you can either continue scrolling through your pictures to rotate more, or simply press MENU to return to the main playback menu.

The Index Display

Sometimes you don't want to look at every photo, one by one. They do take some time to display. So, the Digital Rebel

offers some faster options. One of my favorites is the index display. To access this function, first set the camera to the playback mode by pressing the playback button ▶ . Then, press the index button ⊞ located on the top right of the back of the camera, just below the Mode Dial. The index display will show thumbnail versions of your photos on the LCD monitor in groups of nine.

Of course, these thumbnails are too small to really see much detail, but it is a quick way to review the pictures you have taken. Use the left and right-hand directional cross keys ✥ to scroll through the thumbnails. You can see a single selected image (highlighted in green) by either pushing the playback button ▶ or the enlarge button ⊕ located at the top right of the camera back next to the index button ⊞. You can also go directly to image information by pressing INFO., located in the top left-hand corner of the camera back.

The Jump Button

The other way to move quickly through your images is to use the jump button JUMP , located just above the playback button ▶ on the back left of the camera. I don't like this as well as the index display since you can't see every photo. Pushing JUMP puts a jump bar icon at the bottom of the LCD monitor. Press the left and right-hand cross keys to jump ten frames back or forward.

The Info Button

Probably the most useful playback tool is the info button INFO.. Push this when a photo is displayed, and you get data on how the image was shot (exposure, white balance, ISO speed, and more) plus a histogram – a graph that represents the brightness values of the image. This can be extremely useful when trying new techniques. When you want to see what effect different shutter speeds have on a moving sub-

When photographing close-up or portrait subjects, you may want to use the Digital Rebel's magnification tool to check your focus.

ject, for example, you can take a few shots then check the info to check your results.

INFO. does reduce the image size on the LCD monitor in order to fit this added information. You may need to enlarge

the photo to check focus or other details. This is very impor-
tant, especially if you are using a technique with limited
depth of field (such as close-ups or portraits).

Magnification

The Digital Rebel's ability to zoom in on particular parts of
an image is a very handy advantage. To magnify the picture,
press the enlarge button ⊕ found at the top right corner
on the back of the camera. An enlarged portion of the photo
will be displayed. You can press the enlarge button repeat-
edly to magnify up to 10x on the LCD monitor. That is defi-
nitely big enough to double check important details (i.e.,
examining a person's eyes to see if they are in focus). While
the image is enlarged, you can move around to view differ-
ent parts of the picture using the cross keys ✧ . A small
white locator box will appear in the frame to show you both
how far you are zoomed in and where you are in the photo.

 To zoom back out, push the reduce button ⊖ , found
directly to the left of the enlarge button (also note that the
reduce and index buttons are one and the same). You can
quickly go back to the photo's full size by pressing the play-
back button ▶ . Remember, the LCD monitor will remain
in the enlarged or reduced setting as you move through your
pictures until you either press the playback button or turn
the camera off. The small white locator box will remind you
that you have a magnified view.

Erasing Images

There are several things you can do with the images stored
on your CF card while it is still inside the Digital Rebel. Two
of the most important options to be familiar with are erasing
images and protecting them.

 Erasing images from the memory card is very easy, as it
should be. Ridding your card of unwanted images as you go

As you experiment with different photographic techniques, ask your-self which photos can be discarded and which you'd like to keep.

allows more room for the images you'd like to keep. Examine your photos carefully to see what you are doing right and wrong, then make adjustments and corrections. You may want to save a couple of test shots here and there until you are more comfortable with the camera settings (or the particular photographic conditions you're working with!), but just be aware that the erase button can help you keep your card clear of photos you don't really need to see again.

In order to erase an image, that image must be visible on the LCD monitor. This helps to ensure that you won't erase anything you mean to keep!

Note: The exception to this rule is when you are formatting your CF card, which will erase the card completely. See page 55.)

The image will appear on the LCD monitor right after the shot, but you can also display images using the playback button ▶ . Once you see the image, you can press

the erase button 🗑 to delete it (located at the bottom left of the camera back). If you are in the instant review mode (directly after the picture has been taken), you will see the word "Erase" with the options "Cancel" or "OK." To erase, move the selection to "OK" with the cross keys ✛ and press (SET) .

If you are in playback mode when you press the erase button 🗑 , you get a slightly different message: "Cancel," "Erase," and "All." "Cancel" is the default selection, so you have to deliberately decide to erase an image. If you select "Erase," you will only delete the photo you see on the screen. "All" takes you to another message: "Erase all images?" and "Cancel" or "OK." It's probably not a bad idea that Canon offers a second chance to decide before erasing all the images on the CF card. You may want to scroll through them one last time to be sure you aren't deleting any images you need.

Protecting Images

When you select "All" from erase options, all the images except protected ones will be deleted. The Digital Rebel offers this protection option so that you can save certain images while still cleaning up your CF card for more shooting. To protect a photo, press MENU and use the cross keys to enter the playback menu ▶ . Then, using the cross keys again, scroll down to the Protect option and press (SET) . Now, the protect setting screen will appear, and you will be able to scroll through your images and select which ones to protect. To protect an image that appears on the LCD monitor, simply press (SET) again. When an image is protected, the image protection icon 🔒 will appear below the image (this icon will not be seen during general playback). If you wish to cancel the image's protection, press (SET) again and you will see the protection icon disappear. (Press MENU to exit.) Once you have scrolled through all your images and protected the ones you need, you can use the erase "All" command to get rid of the unprotected photos.

Automated Playback of Images (Auto Play)

The Auto Play option is a fun part of the playback choices. It lets you review the images on the card in the form of a slideshow. You can access this option in the playback menu ▶ under Auto Play. Scroll down to it using the cross keys ✛ , then press ⑤ . The camera will take a few moments to get ready, then the images will automatically change from one to the next in the order they were shot. Each image stays on the LCD monitor for approximately three seconds, though this may vary if you have changed the file size or format. The camera has to read each image before displaying it. You can pause Auto Play by pressing the ⑤ button again, or exit Auto Play by pressing the MENU button.

Connecting to a Television Set

If you want to show off your latest photo outing, simply protect the images on the CF card that you'd like to Auto Play, select erase "All" to erase the images on the card that you don't want, and you're ready to put on your slideshow! If you'd like to view your images on a larger screen than the LCD monitor, you can connect the camera to any television set with monitor inputs. Simply plug the video cable (included with your Digital Rebel) into the "VIDEO OUT" terminal on the camera and the "VIDEO IN" terminal on the television. You will be able to view your images on the television screen as the camera scrolls through them with the Auto Play function. (During this connection, the LCD monitor will shut off.)

Before you connect (or disconnect!) the camera to the TV, be sure that both are switched off, as this will ensure no errant charges flow between them. Also, be sure that the camera is set to the video system format before you turn it off and connect the video cable. To do this, go to setup menu two ⫙2 and scroll down to Video system. You can select either NTSC or PAL (NTSC is standard in North Amer-

Show off your favorite photos by connecting the Digital Rebel to a television set.

ica, PAL is standard in Europe). Now you can turn off the camera and connect it to the switched off television set. Once they are connected, turn the TV on first and then the camera. This protects the camera from shorting out and lets it "sense" the TV connection as it comes on so that it can display there instead of the monitor. (If you find that this option is of frequent use to you, you might consider getting the optional AC adapter so that the slideshow's run-time is not limited by the camera's battery power. The camera will not shut off automatically when Auto Play is in use.)

File Numbering

Though many photographers never use this function, it can be useful when you are taking a lot of images and want to be sure that they maintain an inherent order. The camera

automatically files images into folders in groups of 100 and assigns numbers from 1 to 9999 (it won't number above that – the camera will display an error message). To access your numbering options, select File numbering from setup menu one ᶠᵀᵀ . One choice is to have the numbers count up successively even as you change memory cards. Just select Continuous from the File numbering options. Continuous numbering means that if you are at 0298 on one card and then change cards, the next image – even though it is on a different card – will be 0299, and a new folder will be created at 0300. This is the best option when you need to be sure which CF card is from an earlier shoot! Continuous numbering is also convenient in that it prevents images from having the same file number when you download to the computer. Your second option is to have the camera change the numbering every time a freshly erased or formatted card is put into the camera (always starting over with 0001). This is the Auto reset option, which may best be used when the order of the CF cards is unimportant.

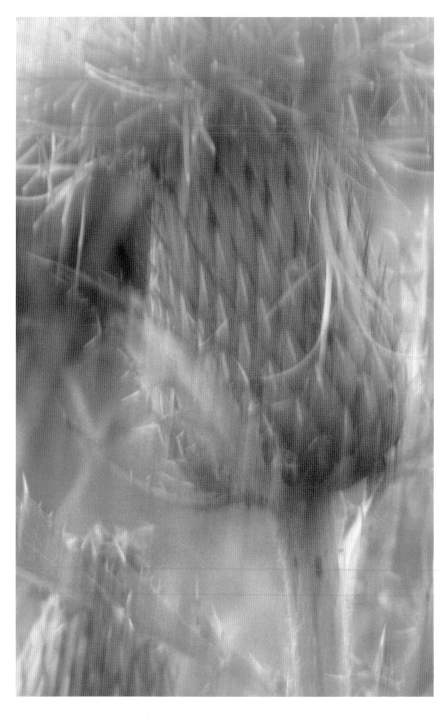

Working with the Computer

Camera to Computer

There are two main ways of getting digital files off of the memory card and into the computer. One way is to insert the card into an accessory known as a card reader. Card readers connect to your computer through the USB port and can remain plugged in and ready to download your pictures. The second way is to download images directly from the camera using a USB interface cable (included with the camera at the time of purchase).

The advantage to downloading directly from the camera is that you don't need to buy a card reader. However, there are some distinct disadvantages. For one thing, the camera generally downloads much slower than the card reader. Plus, the camera has to be unplugged after each use (the card reader can be left attached to the computer). As well as these drawbacks, downloading directly from the camera also uses up its battery power in making the transfer.

The Card Reader & the PCMCIA Card

A card reader is a simple device that plugs directly into your computer, either using USB or FireWire. They can be purchased in the form of single-card reading devices (for use with only one particular type of memory card) or multi-readers (which are able to take several different kinds of cards). After you have plugged the card reader into your computer, remove the memory card from your camera and put it into the appropriate slot

Use an image-editing program to alter your photos in creative ways.

Be sure to burn any images that you know you want to keep onto a quality CD.

The card will often show up as an additional hard drive (on Windows XP and Mac OS IX and X operating systems—for other versions, you will likely have to install the drivers that come with the card reader). The computer may also give instructions for downloading. You may want to follow these instructions if you are unsure about opening and moving the files yourself, but this is much slower than simply selecting your files and dragging them to where you want them.

Card readers can also be used with laptops, though PC card adapters (also called PCMCIA cards—Personal Computer Memory Card International Association) may be more convenient when you're on the move. As long as your laptop has a PC card slot, all you need is a PC card adapter for your particular type of memory card. Insert the memory card into the PC adapter, then insert the PC adapter into your laptop's PC card slot. The computer will recognize this as a new drive, and then you can drag and drop images from the card to the hard drive.

Working with Files

How do you edit and file your digital photos so that they are accessible and easy to use? To start, it helps to create folders specific to groups of images (i.e. Summer Vacation '03, Brian's Graduation, etc.). You can organize your photo folders alphabetically or by date inside a "parent" folder.

Be sure to edit your photos and remove extraneous shots. The photos stored on your computer are using precious memory, so you should store only the ones you intend to keep. Take a moment and review your pictures while the card is still in the camera. Erase the ones you don't want, and download the rest.

Set up one folder for your original, unedited images as a way of isolating them. Then you can copy the images into other folders and edit the copies. This helps to ensure that you don't overwrite your original images with your edits. Once you have downloaded your images onto the computer, you should burn them to a quality CD as soon as possible. CDs take the place of negatives in the digital world. Storing too many images on your hard drive can cause it to crash, and you don't want your only copies of those summer vacation photos to be stored only on your computer when that happens. Set up a CD binder for your digital "negatives." You may want to keep your original and edited images on separate discs (or separate folders on the same disk).

Browser Programs

While the latest Photoshop has an improved browser that can help organize photos, it still doesn't do as well as software specifically made for this purpose. ACDSee (www.acdsystems.com) is a superb program with a customizable interface and some unique characteristics such as a calendar feature that lets you find photos by date. Another very good program with similar capabilities is iView Media (www.iview-multimedia.com). You may also want to check out Digital PhotoPro (www.moose395.net), which was

designed by professional photographers and has some interesting pro features, including a magnifying digital "loupe."

All of these browser programs include some database functions (such as keyword searches) and versions work on both Windows and Mac platforms (although the most recent versions of ACDSee and Digital PhotoPro are only available for Windows). These programs allow you to quickly look at photos on your computer, rename photos one at a time or all at once, read all major files move photos from folder to folder, resize photos for e-mailing, create simple slideshows, and more.

An important function of browser programs is their ability to print customized index prints. You can then give a title to each of these index prints, and also list additional information such as the photographer's name and address, as well as the photo's file location. The index print serves as a hard-copy that can be used for easy reference (and visual searches). You might want to include an index print with every CD you burn so you can quickly reference what is on the CD and find the file you need. A combination of uniquely labeled file folders on your hard drive, a browser program, and index prints will help you to maintain a fast and easy way of finding and sorting images.

Storing Your Images

Even though digital images are stored as digital files, they can still be lost or destroyed without proper care. Many photographers use two hard drives, either adding a second one to the inside of the computer or using an external USB or FireWire drive. This allows you to immediately and easily back up photos on the second drive. It is very rare for two drives to fail at once (though it is still highly recommended that you burn your images to CD).

Hard drives, Zip disks, and memory cards are all devices known as magnetic media. As such, they do a great job at recording image files for processing, transmitting, sharing,

192

and more. However, they are not good for long-term storage. Magnetic media have a limited life. Most manufacturers won't rate such storage devices beyond 10 years. This is a conservative number, to be sure, but this type of media has been known to lose data in this time span.

There are also a number of malicious computer viruses that can wipe out image files from a hard drive (especially JPEGs). Even the best drives can crash, rendering them unusable. Plus, we are all capable of accidentally erasing or saving over an important photo.

The answer to these storage problems today is optical media. A CD-writer (or "burner") is a necessity for the digital photographer. DVD-writers work extremely well, too, and DVDs can handle about six times the data that can be saved on a CD. Either option allows you to back up photo files and store images safely.

There are two types of disk media that can be used for recording data: R designated (i.e. CD-R) recordable discs, and RW designated (i.e. CD-RW) rewritable disks. R discs can only be recorded once—they cannot be erased and no new images can be added to them. RWs, on the other hand, can be recorded on and then erased and reused later, and you can add more data to them as well.

However, if you want long-term storage of your images, use R disks rather than RWs (the latter is best used for temporary storage, as when transporting images to a new location). The storage medium used for R disks is more stable than that of RWs (which makes sense since the RWs are designed to be erasable).

Buy quality media. Inexpensive disks may not preserve your photo-image files as long as you would like them to. Read the box. Look for information about the life of the disk. Most long-lived disks are labeled as such and cost a little more. (For small downloads, check out the small disks, called Pocket CDs. These 3.5 inch (~8.9 cm) disks will still fit in the usual CD drive, and they are convenient for transport.)

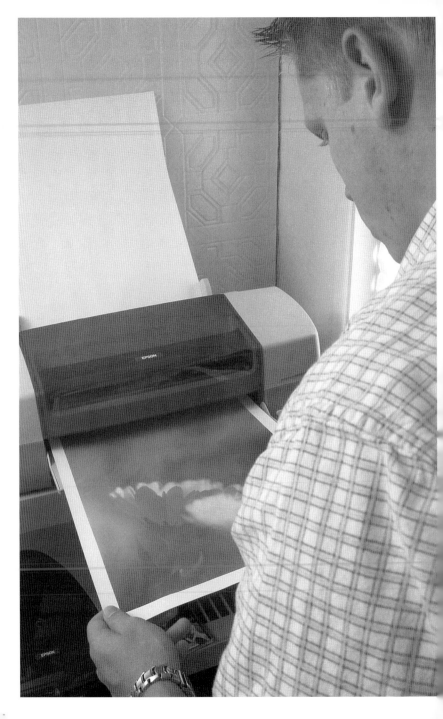

Printing

Direct Printing

The Digital Rebel offers a really neat feature for the modern digital photographer—direct printing from the camera. With certain compatible Canon printers, you can control the printing directly from the camera. Simply connect the camera to the printer using the dedicated USB cord that came with your Digital Rebel.

In addition, the camera is PictBridge compatible (meaning that it can be directly connected to PictBridge printers from several manufacturers). Canon printers that allow direct printing include both the small 4x6-inch dye-sublimation printers and the standard BubbleJet printers (BubbleJet is Canon's inkjet technology).

Note: RAW files cannot be used for the direct printing options mentioned in this section.

To start the process, set up the printer with the proper paper and ink as needed. Then, making sure that both the camera and the printer are turned off, connect the camera to the printer with the camera's USB cord (the connections are straightforward since the plugs only work one way). Turn on the printer first, then the camera—this lets the camera recognize the printer so it is prepared to control it (some printers may turn on automatically when the power cable is connected). Press the playback button ▶ and you will see one of two new icons 🖉 🎝 in the upper left of the LCD monitor to the left of the word SET.

One of the great aspects of using a digital camera is the ability to control and print your own photos.

Optimize picture quality using the Digital Rebel's white balance and parameter settings if you plan to use direct printing for a particular image.

You start the printing process by selecting an image on the LCD monitor that you want to print, then pushing the (SET) button. Now a new screen will appear that gives you choices on how to print: Style (includes Borders/Borderless and a date stamp), [# of] copies, and Trimming. These choices may vary depending on the printer—refer to the printer manual if necessary. Trimming is a neat choice because it allows you to actually crop your photo right in the LCD monitor before printing so you can tighten up the composition if needed. (Remember that cropping a photo will lower the resolution the closer you crop in.)

This printing will not give you the same results as printing from the computer because you have little to no control over the image's color and brightness.

Note: The amount of control you have over the image when printing directly from the camera is limited entirely by the printer. Some printers do allow minimal image control dur-

ing direct printing, others offer none at all. If you really need image control, print from the computer.

If you are shooting a lot of images that you plan to print using direct printing, do some test shots and set up the Digital Rebel's parameters to optimize the prints before actually shooting the final pictures. You may even want to create a custom setting that increases sharpness and saturation (see page 58 for custom parameter details).

Digital Print Order Format (DPOF)

Another printing feature of the Digital Rebel is DPOF (Digital Print Order Format). This allows you to decide which images to print before you actually do any printing. Then, if you have a printer that recognizes DPOF, it will print those specifically chosen images automatically. It is also a way to select images on a memory card for printing at a photo lab. When you drop off your CF card with images selected using DPOF—assuming that the lab's equipment recognizes DPOF (ask before you leave your card)—the lab will know which prints you want. (You may want to jot down image-file names and/or numbers in case the lab equipment is not DPOF compatible. To save yourself the trouble of unnecessary note-taking, call ahead and double check with the lab!)

DPOF is accessible through the playback menu ▶ . You can set the options you want, choosing all of the images or any combination of individual images. Options include: the number of copies, from 1 to 99, of each print selected; the type of print (either a single image per page, index prints, or both); a date-stamp; and file numbering. In the playback menu ▶ , scroll down to Print Order using the cross keys ✥ and press ⑤ . From that point in the menu, select Set Up to determine the type of print, then press MENU. After Set Up, use the cross keys to choose either Order or All and press ⑤ again. Order allows you to select which individual images you want to print, along with their quantity (All selects all the images). Press MENU to exit this screen and

return to the Print Order screen, then press MENU again to save the settings to your CF card.

Digital Prints

The only way you can get a photograph from film is to process the film and print the image, which ususally invovles a certain amount of time. With digital technology, images can be printed immediately after taking the picture. There are multiple choices for printing:

1. *Computer download:* Connect either your camera or a card reader to your computer, then download images to send to your printer.

2. *Direct-print printers:* Some inkjet and small dye-sublimation printers let you connect the camera directly to the printer, then the printer makes a photo print.

3. *Card-reader printers:* These printers have card readers built into them so you can take a memory card from your camera and insert it directly into the printer. It can then print everything from index prints to full-sized images.

4. *Kiosks:* Many photo stores and other businesses are offering self-service kiosks where you can take your memory card in and print images directly from it.

5. *On-line services:* There are many websites that offer services from personal albums that friends and relatives can access with a password, to delivering finished prints from the files you upload.

6. *Photofinishers and mini-labs:* Most photo labs now have the capability to take a memory card, download images from it and return quality prints to you.

Glossary

aberration
An optical flaw in a lens that causes the image to be distorted, or unclear.

Adobe Photoshop Elements
Adobe image-editing software generally considered for an amateur rather than professional audience. Enables quick red-eye removal, photo cropping, contrast and color adjustment, panoramic assist, and more.

AE
See automatic exposure.

AF
See automatic focus.

angle of view
The area seen by a lens, usually measured in degrees across the diagonal of the film frame.

aperture
The opening in the lens that allows light to enter the camera. Aperture is usually described as an f/number. The higher the f/number, the smaller the aperture. The lower the f/number, the larger the aperture.

aperture priority
A type of automatic exposure in which you manually select the aperture and the camera automatically selects the shutter speed.

artifact
Misinterpreted information from a compressed digital image. Appears as color flaws or lines through the image.

artificial light
Usually refers to any light source that doesn't exist in nature, such as incandescent, fluorescent, or other manufactured lighting.

astigmatism
A defect that occurs when a lens is unable to focus indirect light rays on a point.

automatic exposure
When the camera calculates and adjusts the amount of light necessary to properly form an image on the sensor.

automatic flash
An electronic flash unit that reads the light reflected from a subject, fires, then shuts itself off as soon as ample light has reached the sensor.

automatic focus
When the camera automatically adjusts the focusing ring on the lens to sharply render the subject.

ambient light
See available light.

Av
Aperture Value. An abbreviated way to indicate f/stops (aperture settings). This term is also used to indicate Aperture-Priority (Av) mode.

available light
The amount of illumination at a given location. Applies to natural and artificial light sources but not those supplied specifically for photography. Also called existing light or ambient light.

backlight
Light that projects toward the camera from behind the subject.

backup
A copy of a file or program made to ensure that, in the case of the original being lost or damaged, the necessary information is still intact.

barrel distortion
A defect in the lens that makes straight lines curve outward away from the middle of the image.

bit
Stands for binary digit. The basic unit of binary computation. See also, byte.

bit depth
The number of bits per pixel. Determines the number of colors the image can display. Eight bits per pixel are necessary for a quality photographic image.

bounce light
Light that reflects off of another surface before illuminating the subject.

brightness
A subjective measure of illumination. See luminance.

buffer
Temporarily stores data so that other programs, on the camera or the computer, can continue to run while data is in transition.

built-in meter
A light measuring device that is incorporated into the camera body.

bulb
The shutter speed setting that comes after 30". Allows the shutter to stay open as long as the shutter release is depressed.

byte
Eight bits. See also, bit.

card reader
Device that connects to your computer through the USB port. Enables quick and easy download of images from memory card to computer.

chromatic aberration
Occurs when light rays of different colors are focused on different planes, causing colored halos around objects in the image.

chrominance
A form of noise that appears as a random scattering of densely packed colored "grain." See also, luminance and noise.

close-up
A general term used to describe an image created by closely focusing on a subject. Often involves the use of special lenses, bellows, or extension tubes. Also a programmed image control mode that automatically selects a large aperture.

CMOS
Stands for complementary metal oxide semiconductor. A sensor used in digital cameras as a recording medium that converts light into digital images. Uses both negative and positive polarity circuits. CMOS chips use less power than chips with only one type of transistor.

color balance
The sensor's interpretation of the actual colors of the subject.

color cast
A colored hue over the image often caused by improper lighting or incorrect white balance settings. Can be produced intentionally for creative effect.

color space
A template for determining appropriate hue, brightness, and color saturation.

CompactFlash (CF) card
One of the most widely used removable memory cards.

complementary colors
Any two colors of light that, when combined, emit all known light wavelengths, resulting in white light. Also, any pair of dye colors that absorb all known light wavelengths, resulting in black.

compression
Method of reducing file size through removal of superfluous data, as with the JPEG file format.

contrast
The difference in luminance, density, or darkness, between two tones.

contrast filter
A colored filter that lightens or darkens the monotone representation of a colored area or object in a black-and-white photograph.

corrective filter
Used when shooting black-and-white photographs, a colored filter that allows the film to record brightness values as they are perceived by the human eye.

critical focus
The most sharply focused point of an image.

cropping
The process of extracting a portion of the image area. If this portion of the image is enlarged, the pixels enlarge with it and resolution is lowered.

daylight
A white balance setting that renders accurate color when shooting in conditions such as mid day sunlight, with a blue flashbulb, or with electronic flash.

dedicated flash
An electronic flash unit that automatically sets the shutter to the proper synchronization speed and activates a signal in the viewfinder that indicates that the flash is fully charged.

default
Refers to settings automatically selected by the camera or computer unless otherwise specified by the user.

depth of field
The image space in front of and behind the plane of focus which appears acceptably sharp in the photograph.

diaphragm
A mechanism that determines the size of the opening that allows light to pass into the camera when taking a photo.

digital zoom
A zoom effect that does not in fact allow closer focus of the subject, but rather enlarges the digital image and, thereby, enlarges the pixels and lowers resolution.

diopter
A measurement of the refractive power of a lens. Also a supplementary lens which is defined by its focal length and power of magnification.

download
The transfer of data from one device to another, such as from camera to computer or computer to printer.

dpi
Stands for dots per inch. Refers to printing resolution.

dye sublimation printer
Creates color on the printed page by vaporizing inks that then solidify on the page.

EI
See exposure index.

electronic flash
A device with a glass or plastic tube filled with gas that, when electrified, creates an intense flash of light. Also called a strobe. Unlike a flash bulb, it is reusable.

EV
See exposure value.

exposure
When light enters the camera and reacts with the sensor. Can also be the amount of light that strikes the sensor.

exposure index
A rating of the sensor's light sensitivity, usually abbreviated to EI. Similar to an ISO rating.

exposure meter
See light meter.

extension tube
A hollow metal ring that can be fitted between the camera and lens. Increases the distance between the optical center of the lens and the sensor. Decreases the minimum focus distance of the lens.

file format
The form in which digital images are stored and recorded, i.e. GIF, JPEG, RAW, TIFF, etc.

filter
Usually a piece of plastic or glass. Used to control how certain wavelengths of light are recorded. Absorbs selected wavelengths, preventing them from reaching the sensor. Also, software available in image-editing computer programs that can produce filter effects.

flare
Unwanted light streaks or rings that appear in the viewfinder, on the recorded image, or both. Caused by unwanted light entering the camera during shooting. Use of a lens hood can often prevent this undesirable effect.

f/number
See f/stop.

focal length
When the lens is focused on infinity, it is the distance from the optical center of the lens to the focal plane.

focal plane
The plane on which a lens forms a sharp image. Also, the film plane or sensor plane.

focus
An optimum sharpness or image clarity that occurs when camera settings combine to create a precise convergence of light rays from the lens. Also, the act of adjusting the lens to achieve optimal image sharpness.

frame
The outside perimeter of an image or the edges around an image.

f/stop
The size of the aperture or diaphragm opening of a lens. Also referred to as f/number or stop. Stands for the ratio of the focal length (f) of the lens to the width of its aperture opening (f/1.4mm = wide opening and f/22mm = narrow opening). Each stop up (lower f/number) doubles the amount of light reaching the sensor. Each stop down (higher f/number) halves the amount of light reaching the sensor.

GIF
Stands for graphics interchange format. PC image file format.

gigabyte (GB)
Just over one billion bytes.

gray card
A card used to take accurate exposure readings. Typically has a white side that reflects 90% of the light and a gray side that reflects 18%.

grayscale
A successive series of tones ranging between black and white.

guide number (GN)
A number used to quantify the output of a flash unit. Derived by using this formula: GN = aperture x distance. Guide numbers are expressed in either feet or meters.

hard drive
A contained storage unit made up of magnetically sensitive disks.

histogram
A graphic representation of image tones.

hot shoe
An electronically connected flash mount on the camera body. Enables direct connection between the camera and an external flash. Syncs the shutter release with the firing of the flash.

hyperfocal distance
When focused at infinity, there is an area in front of the infinite focus that also appears sharp. The point closest to you that is still in sharp focus marks the hyperfocal distance.

If you then focus the lens on this point, your depth of field increases to include sharp focus of any objects within the range of half the hyperfocal distance and infinity.

icon
A symbol used to represent a file, function, or program on the camera or computer.

image-editing program
Software that allows for image alteration and enhancement.

infinity
A term used to denote the theoretical most distant point of focus.

interpolation
Process used to maintain resolution when re-sizing an image. Fills in additional space by reading the values of adjacent pixels and mimicking them.

ISO
Traditionally applied to film, this number indicates the relative light sensitivity of the recording medium—the sensor, in this case. Can be adjusted for each shot on the Digital Rebel.

JPEG
Stands for Joint Photographic Experts Group. A lossy compressive file format developed by the International Standards Organization. Loss in image quality is not necessarily apparent to the eye, but may effect the extent of quality image alteration possibilities due to insufficient data.

kilobyte (KB)
Just over one thousand bytes.

latitude
The acceptable range of exposure (from under to over) determined by observed loss of image quality.

LCD
Stands for liquid crystal display. A flat screen with two clear polarizing sheets on either side of a liquid crystal solution. When activated by an electric current, it causes the crystals to either pass through or block light.

lens
A piece of optical glass on the front of your camera that has been precisely calibrated to allow focus.

lens hood
A short tube that can be attached to the front of a lens to prevent flare. Keeps undesirable light from reaching the front of the lens. Also called a lens shade.

lens shade
See lens hood.

light meter
Also called an exposure meter, it is a device that measures light levels and calculates the correct aperture and shutter speed.

long lens
See telephoto lens.

lossless
Image compression in which no data is lost.

lossy
Image compression in which data is lost and, thereby, image quality is lessened. The greater the compression, the lesser the image quality.

luminance
A term used to describe directional brightness. Also, a form of noise that appears as a sprinkling of black "grain." See also, chrominance and noise.

macro lens
Used for close-up photography subjects, such as flowers.

main light
The primary or dominant light source. Influences texture, volume, and shadows.

manual exposure
A camera operating mode that allows you to determine and set both the aperture and shutter speed. The opposite of automatic exposure.

megabyte (MB)
Just over one million bytes.

megapixel
A million pixels. Used to describe digital camera resolution capacity, as well as digital image quality.

memory
The storage capacity of a hard drive or recording media.

memory card
Typical recording media of digital cameras. Can be used to store still images, moving images, or sound, as well as related file data. There are several different types, i.e. CompactFlash, SmartMedia, xD, Memory Stick, etc. Individual card capacity is limited by available megabyte storage as well as by the quality of the recorded data; image resolution, for example.

menu
An on-screen listing of user options.

middle gray
An average gray tone with 18% reflectance. See also, gray card.

midtone
Appears as medium brightness, or medium gray tone, in a print.

mode
Specified operating conditions of the camera or software program.

noise
The digital equivalent of grain. Often caused by sensor or other internal electronic heat. Usually undesirable, but may be added for creative effect using an image-editing program. See also, chrominance and luminance.

normal lens
See standard lens.

overexposed
When too much light is recorded with the image.

pan
Moving the camera to follow a moving subject. Creates an image in which the subject appears sharp and the background is blurred.

perspective
The perceived size and depth of objects in an image.

PICT
Short for picture file. File format developed by Apple. Especially useful for compression involving areas of solid color.

pincushion distortion
A flaw in a lens that causes straight light rays to bend inward toward the middle of an image.

pixel
Short for picture element. Base component of a digitized image. Every individual pixel has distinct color and tone.

plug-in
Third-party software created to augment an existing software program.

polarization
Achieved either by using a polarizing filter or software filter effect. Minimizes reflections from non-metallic surfaces like water and glass. Often makes skies appear bluer and less hazy.

RAM
Stands for random access memory. A computer's memory capacity, directly accessible from the central processing unit.

RAW
An image file format that has little or no internal processing applied by the camera. Contains 12-bit color information, more complete data than other file formats offer.

resolution
Refers to image quality and clarity, measured in pixels or megapixels. Also, lines per inch on a monitor, or dots per inch on a printed image.

saturation
Refers to dominant, pure color lacking muddied tones.

sharp
A term used to describe the quality of an image as clear, crisp, and perfectly focused, as opposed to fuzzy, obscure, or unfocused.

short lens
A lens with a short focal length. It produces a greater angle of view than you would see with your eyes.

shutter
The apparatus that controls the amount of time during which light is allowed to reach the sensor.

shutter priority
An exposure mode in which you manually select the shutter speed and the camera automatically selects an aperture to match.

single-lens reflex (SLR)
A camera with a mirror that reflects the image entering the lens through a pentaprism onto the viewfinder screen. When you take the picture, the mirror reflexes out of the way, the focal plane shutter opens, and the image is recorded.

standard lens
A fixed-focal-length lens usually in the range of 45 to 55mm. Gives a realistically proportionate perspective of the scene, in contrast to wide-angle or telephoto lenses. Also known as a normal lens.

stop
See f/stop.

stop down
To reduce the size of the diaphragm opening. Use a higher f/number.

stop up
To increase the size of the diaphragm opening. Use a lower f/number.

strobe
Abbreviation for stroboscopic. An electronic light source that produces a series of evenly spaced bursts of light.

synchronize
Causing a flash unit to fire simultaneously with the complete opening of the camera's shutter.

taking lens
The lens through which the light passes into the camera and onto the sensor.

telephoto effect
When objects in an image appear closer than they really are through the use of a telephoto lens.

telephoto lens
A lens with a long focal length that enlarges the subject and produces a narrower angle of view than you would see with your eyes.

thumbnail
A miniaturized representation of an image file.

TIFF
Stands for tagged image file format. Uses lossless compression.

tripod
A three-legged stand that stabilizes the camera and eliminates camera shake caused by body movement or vibration. Usually adjustable for height and angle.

Tv
Abbreviation for time value. On the camera body, it refers to shutter–priority mode.

USB
Stands for universal serial bus. An interface standard that allows outlying accessories to be plugged and unplugged from the computer while it is turned on. Enables high-speed data transfer.

vignetting
A reduction in light at the edge of an image due to use of a filter or an inappropriate lens hood for the particular lens.

viewfinder screen
The ground glass surface on which you view your image. Features autofocus points.

wide-angle lens
Produces a greater angle of view than you would see with your eyes, often causing the image to appear stretched. See also, short lens.

zoom lens
A lens that can be adjusted to cover a wide range of focal lengths.

Index